GHOSTS OF GOLDFIELD AND TONOPAH

JANICE OBERDING

Haunted America

Published by Haunted America
A Division of The History Press
Charleston, SC 29403
www.historypress.net

Front cover: Photo by Vivaverdi. *Wikimedia Commons.*

First published 2015

Manufactured in the United States

ISBN 978.1.62619.945.3

Library of Congress Control Number: 2015934858

CONTENTS

FOREWORD

Goldfield and Tonopah are small, but they are unique. If there are any better places to live or visit, I am not aware of them. I came to Goldfield over forty years ago. At that time, there were working mines and about six hundred people living here. Today there are only about two hundred, give or take. Goldfield offers travelers an RV park with kids' playground. We have one restaurant—with talk of more—two bars and several gift shops. We have no gas station here in Goldfield, but there are several in Tonopah, some twenty-seven miles north. Stargazers know Tonopah because the town is the best place in the United States to see the night stars.

Highway 95 goes through Goldfield and Tonopah, so we get our share of visitors. For many years, my husband, Richard, and I owned the only towing service in Esmerelda County, and I owned and operated the Glory Hole gift shop that was directly across the street from the Goldfield Hotel. I carried just about any and all antiques and gifts—the stuff people wanted. Many of those who came into my shop were interested in Goldfield's history and ghosts. As a historian and a psychic, I made up my mind to look into both.

Because I was across the street, and my friend owned the building, I began exploring the Goldfield Hotel and contacting the ghosts inside. When my friend sold the hotel and moved away, Lester O'Shea bought it. His plan was to reopen the hotel. This would bring more people to town. Allen Metscher and his brothers opened the Central Nevada Museum in Tonopah, but there was no historical society here to visit. Lester O'Shea and I created the tax-exempt Goldfield Historical Society, and even though we were a small town,

we created a chamber of commerce. Tonopah had the Jim Butler Days, which celebrates Jim Butler, the man who discovered silver there. We wanted something to celebrate Goldfield's unique history. Those who created the Goldfield Days had given up on it. So we created what we called Goldfield Treasure Days. It was popular for many years and has been revived.

My friend Michael O'Connor and I wanted more people to come into our area so we applied for a grant from the state and created Nevada Silver Trails. We successfully operated it for a year and when Pioneer Territory wanted to change their name to attract more tourism, we donated the name. I am proud to say that Nevada Silver Trails continues to this day.

Lester O'Shea never did open the Goldfield Hotel, and somewhere along the way, I became its caretaker. I continued to visit the ghosts in the hotel. I love them all, but my favorite is Elizabeth in Room 109. She is very sweet and young and doesn't like loud noises or bright flashing camera lights. My friends who come from across the country bring flowers as tributes to her. Along the way, television took notice. At first it was the local Las Vegas channels wanting a spooky Halloween story about the decrepit hotel and its ghosts. Then Reno took an interest. Goldfield is about halfway between those two cities.

Both Goldfield and Tonopah are home to me. Tonopah is only a hop, skip and a jump from Goldfield, and that's where the only nearby supermarket is. So I visit the town at least once a week. Goldfield and Tonopah share a rich mining history. The twentieth-century gold and silver rush and many of the men involved in Goldfield mining were likewise linked to Tonopah. Many of Nevada's early movers and shakers came from Tonopah and Goldfield. We are proud of our area, and the Central Nevada Museum is something of which we are especially proud. So is the recently reopened and refurbished Mizpah Hotel. The hotel went through some bad times of being opened and closed, opened and closed. I went there many times when it was opened the second time to see if the Lady in Red ghost was really there—yes, she is real. And you shouldn't wear pretty red shoes around her; she will borrow them.

When national TV started to call about the hotel, I was excited. With film crews coming to town, Goldfield and Tonopah would get the recognition they deserve. On one of those shows, I was to meet and work with Janice Oberding, whom, I was told, was a historian, writer and ghost investigator from Reno. You never know if you'll like somebody or not, but Janice and I hit it off. That was over ten years ago. Since then, we have traveled together, wrote a book about the Mizpah Hotel and have done numerous ghost TV shows, ghost conferences and events. Our interest in Nevada history, ghosts,

reading and cooking has bonded us. We share recipes and cooking secrets as often as a good whodunit. But first and foremost is our love of Nevada history and ghosts. I am not able to get around like I used to since my two falls, but we have the phone and the computer.

Boom and bust—that's the real story of Goldfield and Tonopah. After Jim Butler's discovery of silver, people came to Tonopah seeking their fortunes. Millions worth of gold and silver was pulled from the mines at the beginning of the twentieth century. That was the boom. The bust came within a few years when there wasn't enough to warrant continued mining. But things change. *Ghosts of Goldfield and Tonopah* comes at a time when mining is once again booming and making a strong comeback here in Central Nevada. I am pleased to have written the foreword for Janice's book. It speaks of Goldfield and Tonopah history and ghosts from the perspective of a person who is not only my friend but also a longtime Nevada historian and ghost investigator.

—Virginia Ridgway

INTRODUCTION

For all the words that have been written about them, all the TV shows that have focused on finding them and all the fear surrounding them, no one is quite sure just what ghosts are. The most commonly accepted belief is that they are the spirits, the essence, of dead people—the disembodied, if you will. The desire to communicate with them and to understand more about ghosts and hauntings knows no cultural or geographic boundaries and is nearly as old as mankind itself. Nearly every language throughout the world contains at least one word that translates to the word *ghost* or *spirit*. This demonstrates that ghostly experiences are universal experiences. From the beginning of time, people throughout the world, in all walks of life, have had brushes with ghosts and hauntings.

And yet the fact remains: we still aren't sure what a ghost is. We can delineate and categorize ghosts by types, but this doesn't bring us to a greater understanding of the phenomena. Yes, there is some new and exciting scientific equipment for seeking ghosts and evidence of their existence. And although much has changed in the area of ghosts and hauntings since my first book on Goldfield's haunted history was written back in 2008, much has remained the same. There has been no earth-shattering, scientifically accepted evidence of ghosts and hauntings. But that is not what this book is about. In writing *Ghosts of Goldfield and Tonopah*, I have accepted the premise that ghosts do indeed exist. This is not a scientific textbook on how to investigate ghosts but rather a book of stories, legends and experiences. It includes the stories told to me by those who have experienced the

unexplained, my own experiences and those of others in the quest for ghosts and the legends, for within every ghost story there is some bit of legend. I will leave it to those with a more scientific bent to separate the legend from the science. My primary focus is on the enjoyment of the stories, the legends and the ghost investigations, with their camaraderie and experiences that cannot be duplicated.

As a ghost investigator and historian, I believe that history plays an integral part in every aspect of ghosts, be it investigation, research or the writing of a book on regional ghosts. Regional history is important to us as a society on so many levels; this is especially true regarding ghosts and hauntings. Without a basis of historical fact, how can anyone accurately assess what is or isn't a haunting? Archaeologists can tell us how people lived by examining the artifacts they left behind. Climatologists can tell us what climate and weather patterns people lived through. Architecture and art can show us how people felt about their societies. But the historian who is concerned with people, their mores, their hopes and their dreams often must rely on the written word. Be it diary, newspaper, personal letters et al., in looking at a time before social media, camera phones, voice recorders and news crews, we are left to rely solely on the written word—and here is the rub, for the written word of chroniclers has been filtered through their feelings, their biases and their prejudices. And this tells us what we hold as *history*.

Change, as they say, is inevitable. And so it is with the interest in ghosts. An element of *Entertainment Hollywood*, if you will, has entered the realm. Curiosity about ghostly matters is no longer considered the purview of the weird—and that is a good thing. With all this popularity, Goldfield and Tonopah have been rediscovered by ghost enthusiasts and historians, and more ghostly occurrences have taken place. This shouldn't be surprising. Goldfield is the location of the most haunted Goldfield Hotel, and Tonopah has the Mizpah Hotel. These two locations will continue to draw ghost hunters for a long time to come. That's my opinion, and I'm not going to change it anytime soon. Neither will the stream of ghost enthusiasts who keep trekking highway 95 toward Goldfield and Tonopah, seeking haunted locations and ghosts. Devotees of paranormal television can tell you that Zak Bagans, Nick Groff and Aaron Goodwin have taped some of their *Ghost Adventure* television shows right here on Goldfield and Tonopah. Likewise, Jason Hawes and Grant Wilson of *Ghosthunters* fame, as well as other members of the Atlantic Paranormal Society (TAPS), have spent some television time here. Along with all these TV stars and ghost enthusiasts come the history buffs. It's all but impossible to explore one subject without

touching on the other. By their very natures, ghosts and history are of the past and are thus connected. To the dismay of some historians, there is no denying the connection between history and ghosts. One helps us to better understand the other.

In *Ghosts of Goldfield and Tonopah*, I have used the words *spirit* and *ghost* interchangeably. I make no distinctions between the two and believe them to be synonymous. I have presented history and legend and many of my own experiences at the haunted locations of these two towns. It is my hope that you will enjoy this book, and if you haven't already done so, that you will come to Goldfield and Tonopah and discover this region of Nevada for yourself. There is probably no better place to look for ghosts and to explore early Nevada history than Central Nevada.

CHAPTER 1

SILVER RUSH, GOLD RUSH

JIM BUTLER'S DISCOVERY

Nevada is a state with many haunted regions. Central Nevada, which includes Tonopah and Goldfield, intrigues ghost hunters around the world. The towns of Goldfield and Tonopah may be small, with few residents. But when it comes to ghosts, now that's a different story altogether.

Goldfield! The very name brings to mind a time not so long ago when men and women raced to the Nevada desert, dreaming of gold and of striking it rich. Some of those who came here have stayed on, long after death has claimed them. Their ghosts haunt the cemeteries and the old buildings long forgotten by time.

Back at the turn of the twentieth century, Nevada was faced with a disastrous financial crisis. California's gold rush was fifty years in the past. The Comstock Lode in Virginia City that had pumped millions into the state's economy was long since played out. Most of those who made their fortunes in Nevada's mines had taken their millions and moved on. The state's major industry was mining, but the mines were closing down. Jobseekers left the state, and the population dwindled. Clearly, Nevada's boom camp days were long gone. Most of the state was situated in the Great Basin, dry and barren desert. There was nothing to draw newcomers to Nevada, and the state's coffers were empty. These were the worst of times for the Silver State.

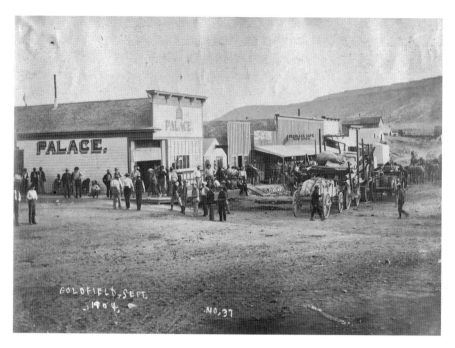

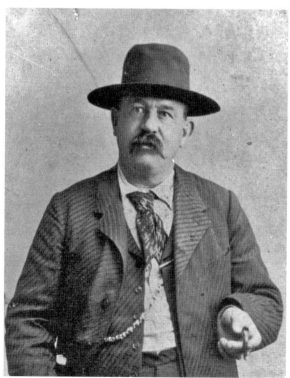

Above: Men, horse-drawn wagons and storefronts in a street in Goldfield in September 1904. *The Boomtown Years Special Collections, University Libraries, University of Nevada–Las Vegas.*

Left: Jim Butler in 1902. *Photo courtesy of Central Nevada Museum.*

However, two discoveries in the central Nevada desert would change everything. The story of those discoveries begins in the town of Tonopah, some twenty-seven miles north of Goldfield.

In the spring of 1900, Belmont prospector Jim Butler was headed to Klondyke, a new mining camp about fourteen miles south of present-day Tonopah, when he made a discovery that would change the course of Nevada history forever. According to a long-told Nevada legend, Jim Butler saved the day when he stumbled on a rich ore deposit near Tonopah Springs. When he picked up a rock to toss at an errant burro, Jim Butler noticed that it felt much heavier than expected for its size. On closer inspection, he wondered if it might contain silver. The burro and its misbehavior were quickly forgotten as Butler gathered several rocks for assaying in Klondyke. This would prove to be his lucky day, but Jim Butler didn't realize this at first. The assayer in Klondyke dismissed the ore samples as worthless. Rather than toss the samples out, Butler kept a few of them and later showed them to his wife.

She encouraged him to have another assayer look at the ore. In the meantime, Jim Butler and his friend Tasker Oddie, who would later become governor of Nevada, wasted no time in forming a partnership and staking several claims, including one called the Mizpah Mine (the site of the present-day Mizpah Hotel). Sure enough, the ore samples assayed at $200 a ton. Just as it had during California's gold rush and Virginia City's silver lode, word got out, and it quickly spread. Within the year, $4 million in silver ore would be mined, and hundreds of people came rushing to the tent city of Butler (later renamed Tonopah) hoping to strike it rich, just as Jim Butler had done.

Among them were Harry Stimler and William Marsh. The two young prospectors combed the desert surrounding Tonopah Springs only to come up empty-handed each and every time. In the fall of 1902, they decided it might be wise to prospect in a different location. Unsure where to look, they were easily swayed by the stories from Tom Fisherman, an old Shoshone, about the rich ore he had discovered to the south. They listened intently as Fisherman explained where the ore was located. As if to illustrate his point, he opened his hand and held out a large ore sample. Marsh and Stimler were impressed and wanted to start out at once.

Eager as they were, they still needed supplies. And supplies cost money, more money than either of them had. So they approached Jim Butler, who readily agreed to grubstake the adventure. With a wagonload of supplies, Stimler and Marsh headed south out of Tonopah on a stormy late November morning in 1902. When they arrived at Rabbit Spring, sand and dust was

stirring as far as the eye could see. Undeterred, they made camp in the howling wind and spent the next several days prospecting in the area.

With winter approaching, bone-chilling temperatures swept across the desert and hung in the air. Stimler and Marsh were young and hardy. They had come for gold and would not turn back. Their efforts paid off early in December when they stumbled on what Tom Fisherman had called Gran Pah. They had found it! They had discovered gold ore near Columbia Mountain, just as the old Shoshone had told them.

Harry Stimler's Strange Death

After their discovery of Gran Pah's gold near Columbia Mountain, fate smiled on William Marsh and Harry Stimler. William Marsh went on to be a

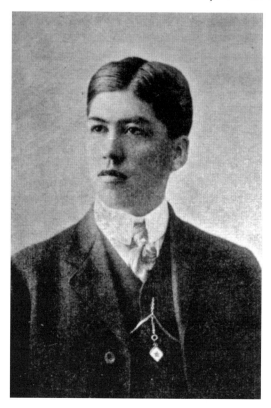

successful Nevada politician, while Harry Stimler's success was great but transitory. His financial standing couldn't be counted on. Eventually, his youthful first marriage ended in divorce, but his second union would last the rest of his life. The young Native American was well liked and affable; money came and went easily for him. While his co-discoverer, William Marsh, thrived in Nevada politics, Harry was content to stay in mining, particularly speculation.

In later years, he attained wealth as a successful entrepreneur, selling mining stocks throughout Central Nevada and the Death Valley area. One constant about Harry Stimler was

Young Harry Stimler in 1907. *Photo courtesy of Central Nevada Museum.*

his habit of sitting with his back to the wall. This came from superstition and his belief that the spirit world had shown his sister a vision of his impending doom.

When he was a child, she foresaw him being shot to death and warned him to never sit by a window. According to Celesta Lowe in her July 1967 article "The Hex of Harry Stimler" for *Golden West True Stories of the Old West Magazine*, this premonition would forever haunt Harry Stimler. Careful as he was, he could not change destiny.

August 22, 1931, was just another scorcher in Tecopa, a small Death Valley town situated in the Mojave Desert. For Harry Stimler, it was to be the day he had feared all his life. He had come to Tecopa to check some gold mining prospects. At the Tecopa Mercantile, he was sitting in his car talking to his passenger when Frank A. Hall, the storekeeper, walked up to the driver's side of the car and shot him in the leg and abdomen. Hall then turned the gun on himself; thus questions surrounding the shooting went unanswered.

Harry Stimler died in the ambulance en route to Barstow, California. In her book *Fire and Forge*, Kathleen L. Housley calls Stimler's killing the most famous murder and suicide in Tecopa; it's certainly a sad ending to the story of Harry Stimler.

THE MIZPAH OPENS...FOR THE FIRST TIME

November 1908 brought bitter cold weather to Central Nevada. By the middle of the month, the temperatures had dropped twenty degrees below the average, setting record cold temperatures. This wasn't enough to deter hardy Tonopahans from turning out in full force to celebrate the grand opening of the Mizpah Hotel. Five stories tall, the Mizpah was the tallest building in Nevada and would hold this distinction until the Mapes Hotel was built in Reno in 1947. Over in Goldfield, the much larger Goldfield Hotel had recently opened, and now Tonopah had its own elegantly modern twentieth-century hotel. Prominent Nevada businessman George Wingfield, who had a financial interest in the Goldfield Hotel, had been instrumental in getting the Mizpah Hotel opened. Both hotels were designed by the Reno architecture firm of Holesworth and Curtis, and that is where the similarities end—or do they?

The Mizpah Hotel was built near the Mizpah Mine and is the namesake of the mine. Belle Butler (Mrs. Jim Butler) named both for *Mizpah*, a word

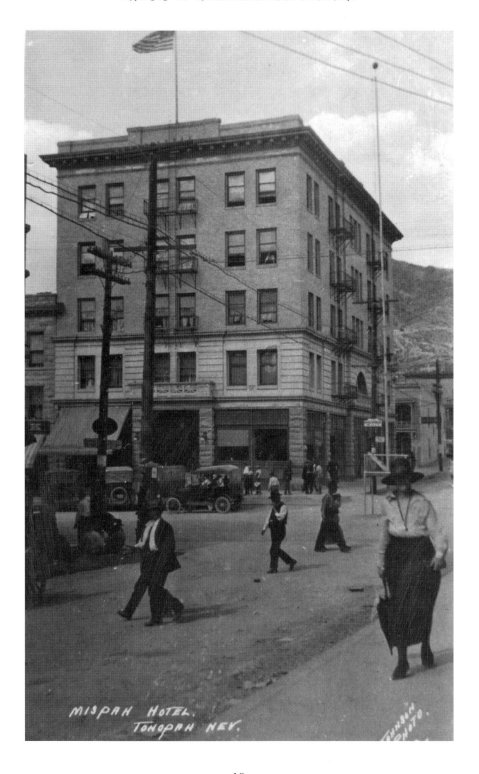

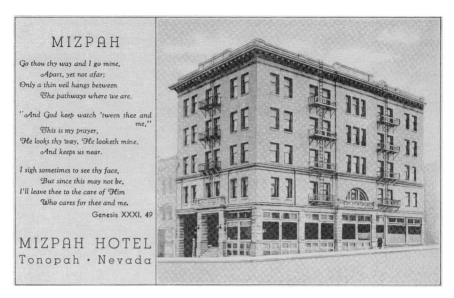

A view of the Mizpah Hotel from an old postcard. *Author's collection.*

Opposite: Mizpah Hotel, circa 1914. *Photo courtesy of Central Nevada Museum.*

in her favorite bible passage, Genesis 31:49. Like any historic building, the Mizpah Hotel has its legends and its ghosts; its proximity to the old Mizpah Mine practically guarantees a ghost. The deaths and murders that have occurred in the vicinity may well account for some of the strange and ghostly happenings at the Mizpah.

In 2011, after several years of being boarded up and closed, the Mizpah Hotel was refurbished and reopened on August 27, 2011, by owners Fred and Nancy Cline. Among the dignitaries and well-wishers were Nevada governor Brian Sandoval and former governor Richard H. Bryan. Nancy Cline's roots go back to early Central Nevada when her great-uncle Harry Ramsey (Skidoo discoverer) made his fortune grubstaking miners in Tonopah and Goldfield. Mrs. Cline's grandmother Emma Ramsey also served as the early Goldfield postmistress.

With the historic Mizpah Hotel as its centerpiece, Tonopah is once again set to thrive, ghosts and all.

CHAPTER 2
TONOPAH'S MIZPAH HOTEL GHOSTS AND LEGENDS

OLD MINER'S GHOST

The ghost of a grizzled old miner is said to roam the hallways of the Mizpah Hotel, making a nuisance of himself by knocking on room doors and awakening hotel guests at all hours of the day and night. Since the hotel was built near the entrance to Jim Butler's Mizpah Mine, the miner probably feels right at home here. It's been suggested that he is the ghost of a man who lost his life in a mining mishap here in Tonopah. This well could be. Although mining deaths were not common in Tonopah and Goldfield, they did happen.

The worst mining disaster in Tonopah happened on February 23, 1911, at the Belmont Mine, in which seventeen men lost their lives. Some people believe that this spirit is the ghost of one of those unfortunate men or that of another who lost his life in the mine. Reading through the *Biennial Report of the State Inspector of Mines, 1913–1914*, it would seem that most of the men who lost their lives in mining accidents were young, but this specter is not. Perhaps the ghostly old miner is the ghost of a long ago prospector.

Still, the question remains: why does the ghostly miner bother hotel guests like this? Maybe he is only looking for someone…or something. He is usually seen in the hallways and around the elevator. But don't waste your time trying to talk with him. Psychics have attempted to learn his identity and

to communicate with him, but the miner doesn't seem to be interested in conversation. He keeps to himself until it's time to wake a sleeping guest, and then he's off, knocking on doors. How is that for an early morning wake-up call?

During a pre-opening paranormal convention at the Mizpah, guests had problems with their door keys and locks. It seems that some keys mysteriously stopped fitting into their locks. Hotel staff members were baffled. When called to try a particular key, it would fit fine. However, an hour later, it would not, and no amount of jiggling would make the key work. One of the attendees suggested this was the work of the old miner's ghost. He used to wreak havoc by knocking on doors and making brief appearances in the elevator; now he was playing with the locks and keys. New locks were put on the doors, and the problem was solved. Now, if only the old miner would stop knocking on the doors…

The Death of Key Pittman

If you're staying at the Mizpah, you just might receive a visit from an elderly man who happens to be a ghost. If you should wake to see him peering down at you, don't worry. It's only the ghost of Key Pittman. He pays no heed to check-out time. The Mizpah was one of his favorite hangouts in life, so it's no wonder the ghostly senator has been seen in the hotel on several occasions since his death in 1940. Like so many of early Nevada's high-powered and prominent men, Key Pittman arrived in Tonopah by way of the Klondike gold rush, where he'd joined thousands of others in the quest for the elusive gold. Unsuccessful in Alaska's gold fields, Pittman met and married his future wife in 1901. That same year, they came to Tonopah, where he opened a law practice in the thriving town. As he became more successful, Pittman entered Nevada politics. Eventually, he would be elected a United States senator.

Central Nevada was home to Pittman. He especially liked good times with friends at the Mizpah. Perhaps this is why he stays on. If you doubt this, consider the following:

Back in the 1990s, before the Mizpah closed the last time, my family and I went to Tonopah to see if we could contact the Lady in Red ghost. Her story intrigued us, and we hoped we might catch a glimpse of her. We had dinner and took up our positions in the fifth-floor hallway. We waited and waited.

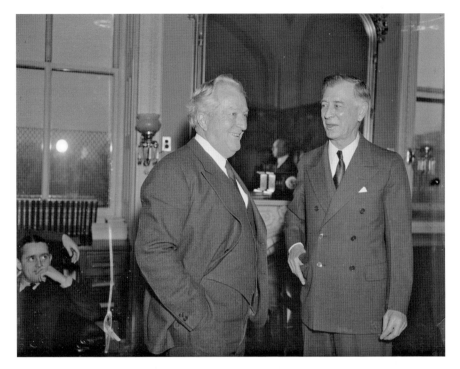

Senators Pat McCarran (left) and Key Pittman (right). *Library of Congress.*

By 3:00 a.m., we were ready to call it a night. For whatever reason, it seemed the Lady in Red ghost was a no-show.

Suddenly, there she was. At least, we thought it was her. A wispy green mist slowly floated from one side of the hallway to the other. Too stunned to take photos, we all agreed that we'd seen the ghostly woman, although it might have been anyone. Off to our rooms we went.

But when I climbed into bed, I couldn't sleep. A bright red light was shining in my window from across the street. I turned my back to the window and drifted off. A few minutes later, I was startled awake by a humming sound. I sat up and saw an old man floating near the ceiling. He was encircled by a red light and seemed to stare down toward me. He wasn't looking at me but in my direction. I sat up and said, "Please, whoever you are. I've got a long drive ahead of me tomorrow, and I need some sleep." Covering my head with the pillow, I went back to sleep.

The next day, I told my mother-in-law what happened, and she got very excited.

"What did he look like? Was it Key Pittman?" she asked.

I didn't have a clue what Key Pittman looked like. The old man I saw looked sickly, that's all I could tell.

Well, she wasn't done. As soon as we got home, we had to go to the library. My mother-in-law had an idea. She pulled me to the Nevada section and started poring over books. Finally, she found what she was looking for and showed me a picture of a group of men. "Is the old man here?" She asked.

He was. "That's him," I said.

She really got excited then. "That's Key Pittman! I knew it…I just knew it. You saw the ghost of Key Pittman. Now I really believe that bathtub story."

The story of how Key Pittman posthumously won an election first appeared in print in the 1963 book *The Green Felt Jungle* by Ed Reid and Ovid Demaris. Since that time, the tale has developed into the legend that will not go away; it's a bitter bone of contention between Nevada historians. Both sides of the argument hold strong opinions as to where Key Pittman actually was when he died of a massive heart attack on November 10, 1940. Most believe he was in Reno, either at the Riverside Hotel or Washoe General. But

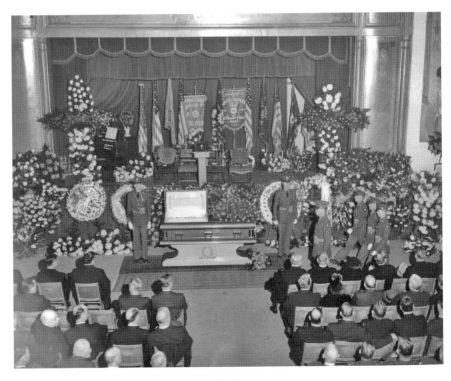

Funeral of Senator Key Pittman. *Author's collection.*

according to the legend in *The Green Felt Jungle*, Senator Pittman was some 250 miles south in Tonopah when death claimed him. Fearing the loss of an important election, his fellow democrats kept Pittman's body on ice in a Mizpah Hotel bathtub until after he won reelection. Then, only after he was declared the winner of the race was his death announced. This feat would have required a large bathtub and an enormous amount of ice—not an impossible task, judging by the size of the claw-foot bathtubs at the Mizpah. When considering the validity of the bathtub story, it is also important to note the need to transport the deceased to Reno for his funeral.

According to *The Green Felt Jungle* authors, a political maneuver by Governor Carville only adds to the story's credulity. Shortly after Key Pittman's death was announced, Governor Carville appointed himself to Pittman's vacated senate seat, thus moving Lieutenant Governor Vail Pittman (Key's younger brother) to position as governor.

Among those who claimed that Pittman was alive after the election were his wife, Mimosa, and Sister Seraphin, a St. Mary's Hospital official. Mimosa later wrote that she had visited him at the Washoe General Hospital shortly before he died. Former Nevada state archivist Guy Rocha has attempted to dispel the myth of Pittman's posthumous win. But then again, suppose the tale is true, and several dozen people conspired to keep the sordid secret…

Lady in Red Ghost

The beautiful and tragic Lady in Red is by far the most famous ghost in residence at the Mizpah Hotel. In life, she was a naïve and relatively inexperienced member of the world's oldest profession who plied her trade in the hotel. Though her origins are, for the most part, unconfirmed, it is certain that she was murdered in front of Room 502 on the fifth floor of the Mizpah Hotel. She was said to have been caught off-guard by a jealous lover who strangled her to death. Some say she was also stabbed. Since her premature death in the early 1920s, her presence has been widely reported by hotel staff and guests; footsteps are heard in empty hallways, numbers have lit up on unplugged keno boards and pearls—like the ones she wore the night she was killed—have been found on guests' pillows.

Several years ago, I was told the story of the Lady in Red ghost and how she delighted in playing with the unused keno board that hung in the Mizpah gaming area. As a former keno writer myself, the story intrigued me. What

if a ghost really could play with the board? If a game were in progress, this could certainly wreak havoc between those who saw their lucky numbers flash on the board and those who had to explain to them that it was simply a malfunction or a ghost. But the keno game was no longer operating at the Mizpah, so the Lady in Red was free to choose her numbers any time she wanted. And apparently she did so, often. Or so the story went…

Jim Butler Days 2011 found me in the Mizpah Hotel with my husband, Bill, and Virginia Ridgway. We were there being afforded a glimpse of the Mizpah Hotel's renovation, a work in progress. As we made our way through the workshop area of the basement, I spotted the old keno board and suddenly stopped. If the Lady in Red were still in residence, perhaps she would do me a favor. After explaining to the others about the ghostly woman's supposed propensity for playing with the keno board, I pointed toward the board and said, "Please light up number twenty-eight."

She didn't. Disappointment surged through me. Maybe she was upstairs overseeing the work that was being done to bring the hotel back to its former beauty. Maybe she'd lost interest in keno and was ignoring me. Reminding myself that ghosts don't respond on command, I continued through the basement area.

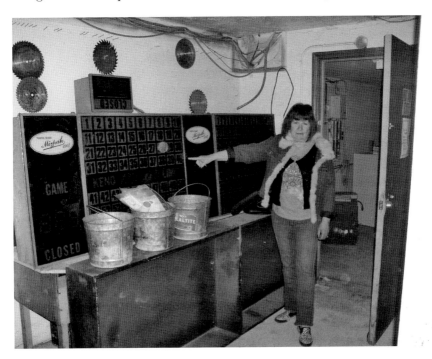

Author with haunted keno board at the Mizpah Hotel. *Photo by Bill Oberding.*

Later that week, I was back home and downloading my photos. Carefully eyeing each for anything anomalous, I came to the one of me pointing toward the keno board. If only the Lady in Red had lit up number twenty-eight…but wait! There on number twenty-eight was a nice bright orb! Maybe she had done me a favor after all. Perhaps it was only a coincidence. Yes, perhaps, but then again, you just never know.

Apparently, the Lady in Red ghost is selective about who she appears to. According to legend, anyone lucky enough to see the Lady in Red ghost will not only be followed throughout the hotel by her but also might find a single pearl left on the pillow or nightstand. This is her way of making a fashion statement, perhaps. During the Roaring '20s, long strands of pearls were the must-have fashion accessory for women from all stratum of society. From flappers to the first lady, the pearl was de rigueur.

The Lady in Red ghost is the bane of the housekeeping department. Room 502 is especially troublesome. When they clean a room, the housekeeping staff members want everything tip-top, as it should be. This naturally includes a well-made bed. But the Lady in Red likes nothing better than to leave indentations of her ghostly handprints on the bedspread. One wise young lady even went so far as to ask the Lady to kindly refrain from her antics. Hopefully this will work.

During their investigations, ghost hunters sometimes use what they call trigger objects, something that was important to the ghost they are attempting to contact. Since the ghostly Lady in Red favors red apparel from her dress to her shoes, ghost investigators will use red shoes as trigger objects when trying to photograph her or record electronic voice phenomena (EVP). Whether you are a ghost investigator or not, remember that if you bring a pair of pretty red shoes with you to the Mizpah, there's a good chance they will be misplaced. But not to worry, the Lady in Red only wants to borrow your shoes for a short time. She will return them…eventually.

HAUNTED ELEVATOR

A lot of ghostly activity happens in the Mizpah's old-fashioned elevator. In the early 1980s, the Lady in Red made an appearance to a man who thought ghosts and hauntings were nonsense, foolishness on the part of anyone who believed in such. His brush with the paranormal came

unexpectedly. He happened to be a member of a local men's club that was holding its luncheon meeting at the Mizpah. Once the meeting was adjourned, some of the men found their way to the bar. Others wandered through the hotel, admiring its early Nevada décor. The gentleman in this particular story didn't partake of alcohol. Rather than hang out at the bar, he climbed the stairs to the fifth floor. There he got in the elevator and made his way down, stopping at each floor. After exploring the second floor, he got in the elevator and pushed the button for the lobby. To his amazement, the elevator started going up. He punched the button again and again; the elevator, as if it had a mind of its own, continued its ascent to the top floor.

When the elevator stopped on the fifth floor, a nicely dressed, attractive woman stepped in. She gave the gent a friendly nod and a smile. "Good afternoon," he said, pressing the down button for the lobby.

He chatted with her during the elevator's descent. When the elevator arrived at the lobby, the door opened, and he gallantly stepped aside for the lady to walk out ahead of him. Much to his surprise, he was alone in the elevator. How on earth, he wondered, had the lady gotten past him with his having seen her? The only explanation was one he didn't want to think about.

He didn't drink, but this experience was so disconcerting that he wanted a drink. No, he *needed* a drink. He hurried to the bar and asked the bartender for a double anything. Then, turning toward the other men at the bar, he told them about his unusual experience in the elevator.

One of his friends asked, "Did she talk to you?"

"No," he replied. "I guess I carried on a one-way conversation. She merely smiled and nodded."

The bartender placed his double in front of him, and he gulped it down.

"What was this lady wearing?" someone asked.

"Some kind of a red dress," he answered. "I don't know much about women's fashions, but it looked to be woolen and red."

The man smiled and said, "You've just been in the elevator with our Lady in Red ghost who resides on the fifth floor."

The teetotaling gent ordered a refill and chugged that down as well. Thus initiated into the world of doubles and ghosts, he left the hotel for who knows where. He may have even reconsidered his stance on ghosts.

MUSIC IN THE ELEVATOR

During the 1980s, people occasionally complained that the Mizpah elevator seemed to run of its own volition. It would run up to the upper floors, doors would open, music would be blaring—and not a soul would be on board. In early 2011, the elevator wasn't working; repairmen worked feverishly to get it up and running in time for the hotel's grand reopening. One day while they worked inside the elevator, two men heard continual music and wondered where on earth it was coming from.

Curiosity got the better of them. They ran out of the elevator, telling everyone within earshot about the mysterious music. Finally, others stepped inside the elevator and listened. They, too, heard music. After a cursory search of the elevator, the repairmen opened its ceiling and discovered a jukebox. But how could it be responsible for the music? The jukebox hadn't been activated in years. For that matter, it wasn't even plugged in.

Taunting laughter and whispers have also been heard by those riding the elevator. While in the elevator, several people have heard a voice saying, "Get out!"

WHO WALKS THE FLOOR?

The ghost of a little boy haunts the hallways of the Mizpah. He's usually described as being dressed in clothing of a century ago, but not always—the ghostly child has also appeared in more modern attire.

"As if he just stepped in off the street," said one witness. The little ghost enjoys knocking the Do Not Disturb signs off door handles and appearing before startled new help at the hotel. The little ghost can be mischievous, as in the case of a couple who were staying in a room on the floor. After an hour of trying to sleep while the sound of heavy footsteps paced back and forth overhead, the husband finally called the desk to complain. Would someone please tell the person in the room directly above them to be quiet?

The desk clerk had heard the complaint before and offered to move the couple to another room. Nothing doing; they would stay right where they were. But someone had to talk to the person on the next floor.

"I am sorry sir, but that room is unoccupied," the desk clerk informed the weary man.

DON'T TAUNT THE GHOSTS

My friend Richard St. Clair (of Empathic Paranormal) has investigated ghostly goings on all over Nevada and California. Recently, he shared this story of his rather strange experience while staying in Room 503.

Cimarron "Cim" Sam and I were going down to Goldfield to see Virginia Ridgway. It had been a long drive, and we decided to spend the night at the Mizpah; we wanted to see it anyway, so we checked in. After lunch, we went up to the room. I looked around a moment and announced, "Okay, let's see what you've got!"

"Richard! Don't do that. Taunting isn't wise."

I laughed it off. I wanted to get some great evidence, and I wasn't being threatening or provoking, just asking for the ghosts to show me what they could do. We sat on the bed, and it hit us just how exhausted we were. A nap was in order. And I promptly fell asleep.

The nightmare was immediate. I dreamed that something was trying to overtake me. It was horrible. I kept trying to escape, but I couldn't. Whatever it was, it was about to overtake me and there was nothing I could do. I must have cried out in my sleep, because Cim was trying to wake me. But he couldn't. He shook me and called my name. I was still sleeping and still dreaming. Whatever it was it wanted to overtake me. Finally Cim was able to wake me from the horrendous nightmare.

It had shown me what it had. And it was one of the most frightening experiences I've ever had in the paranormal. And I made a promise to myself to never taunt a spirit. It might be more than I bargained for.

WHO GOT THE LOOT?

Money can be the root of all evil; it can also be a good reason for a haunting. The two ghosts in the basement of the Mizpah Hotel would no doubt agree. The basement was originally the first floor of the Mizpah Hotel. During that time, several businesses were located here, including the post office and a bank. To ensure the safety of the bank's deposits, a secure, burglar-proof vault was built. Its ceiling and two-foot-thick walls were made of concrete and steel. Nature had provided the perfect floor: hard Nevada earth. There was no need to

Mizpah Hotel basement with orbs. *Photo by Bill Oberding.*

worry about flooring, and the ground was left intact. All the valuables were safe—or so the bankers thought.

They realized their error when the vault door was unlocked a few months later; to their astonishment, the vault was empty. In the middle of the vault floor was a large hole. The bankers looked down and discovered that some clever thieves had dug their way into the vault. After grabbing the gold and other valuables, the robbers fled through the tunnel.

Two bank employees rushed down the tunnel to reclaim the stolen loot and apprehend the brazen thieves. They returned empty-handed and explained to the awaiting crowd that they'd discovered the two robbers dead in their tracks. Mysteriously, the gold and valuables had vanished. The story goes that three men devised the plot to rob the bank. Two went down to get the gold, and when they returned topside, the third man killed them and fled with the loot. Whoever he was, he made a clean getaway, never to be apprehended. No wonder the two ghostly men have stayed on.

Those involved in ghost investigations of the basement have experienced feelings of despair and recorded the sounds of weeping and

Mizpah Hotel haunted basement. *Photo by Bill Oberding.*

moaning. During an EVP session, an investigator asked, "Did something happen to you?"

The response was a clear, "Yes."

When asked to explain, the voice said only, "Oh, I see."

Let the ghostly Lady in Red and the other ghost wander the halls of the hotel; these two ghosts prefer to keep a lonely vigil in the basement. They are up for some ghostly pranks, however. The lights are their favorite tool. Those in the basement go on and off when least expected. Most people just get used to this. Some have found the lights disconcerting, especially when one is alone and suddenly the lights flicker off and then on, as to say, "We're here, and we're staying until we see justice served." That might be a long time, a very long time indeed.

The Goldfield Hotel Ghosts and Legends

A third hotel, larger and more expensive than the others is promised by the fortunate owners of the Hayes, Monnette lease (on the Mohawk Claim No. 2) Messrs. Hayes, Monnette, Benedict and Smith. These gentlemen out of the generous returns received from their mining operations in Goldfield, have concluded to erect a $200,000 brick hotel building, and its construction will begin as soon as the plans which are now in the hands of a Reno architect are complete.
—Goldfield News, *December 1, 1906*

Goldfield Hotel Beginnings

After fire completely destroyed the original Goldfield Hotel, new owners commissioned Reno architects Morrill John Curtis and George E. Holesworth to design and rebuild another hotel on the same site at the corner of Crook and Columbia Streets in 1908. The town was growing, and visitors were arriving daily. The hotel's owners wanted a fine hotel that could accommodate them. With four floors, 175 rooms, an unsurpassed dining room, and a well-appointed lobby, the Goldfield Hotel was elegance the likes of which this desert town had never seen.

The *Goldfield Review* of November 23, 1907, said, "The new Hotel Goldfield which is rapidly nearing completion will be one of the finest caravansaries on the Pacific Coast and certainly will be untouched in Nevada."

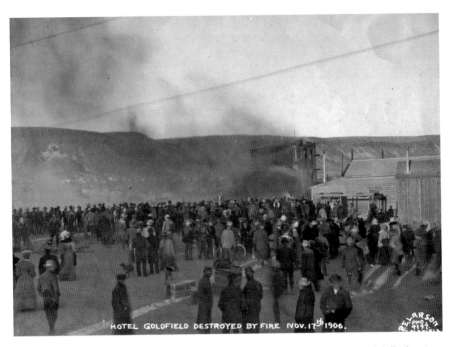

Goldfield Hotel Fire November 17, 1906. *The Boomtown Years, 0300106, Special Collections, University Libraries, University of Nevada–Las Vegas.*

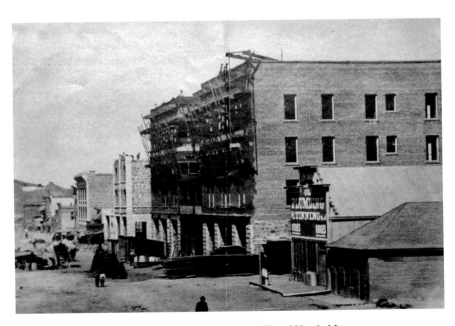

Construction of the Goldfield Hotel. *Photo courtesy of Central Nevada Museum.*

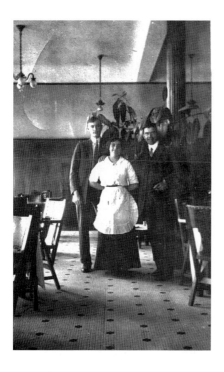

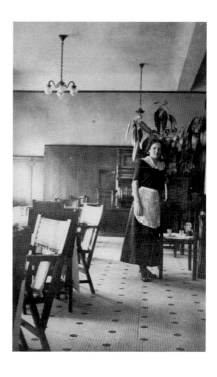

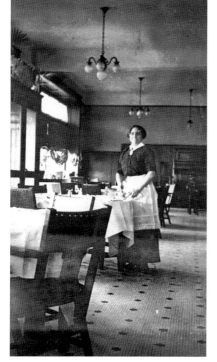

Above, left: Employees of the Goldfield Hotel Palm Restaurant. Note the potted plants in comparison to the desert landscape of the time. *Photo courtesy of Central Nevada Museum.*

Above, right: An employee of the Goldfield Hotel Palm Restaurant. Note the piano in background. *Photo courtesy of Central Nevada Museum.*

Left: An employee of the Goldfield Hotel Palm Restaurant. *Photo courtesy of Central Nevada Museum.*

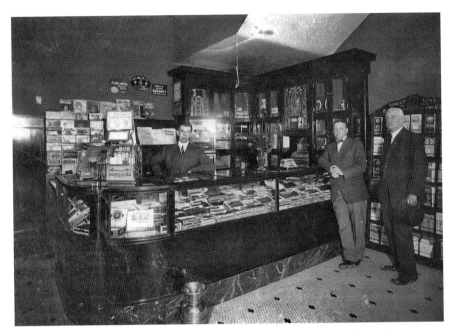

The cigar counter of the Goldfield Hotel, circa 1909. *Photo courtesy of Central Nevada Museum.*

That same year, author Bessie Beatty described the Goldfield Hotel in her book *Who's Who in Nevada*: "The hotel is built of stone and brick, four stories high, and has two hundred rooms. The furniture was purchased in Chicago at a cost of $40,000. The house is provided with all the modern conveniences to be found in a hotel on Broadway, New York, and is considered one of the marvels of the desert."

The praise was warranted. There in the middle of the Nevada desert stood the grand and new Goldfield Hotel. Nothing had been left to chance. The hotel offered fine dining in the Palm, a large restaurant; two bars, from which flowed the finest French champagne; a billiard room; and a barbershop. Every room was lushly carpeted and had its own telephone that was connected to the hotel's central switchboard. Rich velvet drapery covered the windows, and exquisite tile adorned the lobby floor.

On January 15, 1908, the hotel opened for business under the management of attorney J.F. Douglas, who had purchased the failing previous Goldfield Hotel and successfully managed the hotel right up to the night of November 17, 1906, when fire swept through the building, burning it to the ground. As flames engulfed the wooden building, people jumped out of the second-

story windows to safety. Two men were not so fortunate. Businessman A.H. Heber and former Denver, Colorado judge J.M. Ellis lost their lives in the fire. According to one newspaper report, Ellis's head was dismembered and all that remained of the men were a few charred bones and personal affects, which relatives identified. In paranormal research, one prevalent explanation for ghostly activity is sudden unexpected and violent death. The deaths of Ellis and Heber certainly fit this category. There is no evidence that either Ellis or Heber haunts the Goldfield Hotel that was built on the ground on which they perished. It is merely one theory why some of the unexplained activity occurs in that section of the old hotel.

No expense had been spared in building and decorating the new Goldfield Hotel, known as the "Gem of the Desert." For a brief time in 1909, the hotel even offered its own newspaper.

But the town was quickly losing its luster. Everyone was packing up and leaving. There was no longer that get-rich-in-a-day excitement, no jobs and fewer tourists.

Despite all its costly uptown furnishings, the hotel was unable to pay its operating costs and expenses. In 1910, the case of *Judell et al. v. Goldfield Realty Company Co.* was decided by the Nevada Supreme Court. As owner of the Goldfield Hotel, Goldfield Realty Co. owed Judell $901.10 for goods, wares and merchandise and had been ordered to pay by a lower court.

The defendant, Goldfield Realty Co., didn't want to pay and argued that its manager and secretary were not authorized to bind the company in the execution of the promissory note. The Supreme Court saw it differently and ruled in favor of the plaintiff. The hotel continued to be beset by cash flow problems.

Then, as now, no one wanted to receive a large power bill. In 1913, the Goldfield Hotel Company took its power bills seriously and succeeded in having its rates reduced. The following case was listed in the *Reports of the Railroad and Public Service Commissions of Nevada*: "Case No. 47—Alleged Excessive Electric Rate. During the month of June, 1913, the Goldfield Hotel Company of Goldfield made a complaint against the Nevada-California Power Company, alleging excessive rates for light and power. The complaint was disposed of by the general rate reduction made in Case No. 44."

After the 1923 fire that destroyed most of Goldfield, the hotel's billiard room was used as the town's temporary post office. Over the next thirty years, the hotel would see a succession of owners come and go. None of them stayed very long, and none was able to make the hotel a success.

At one point, the state of Nevada considered buying the hotel. In 1957, the legislative commission conducted a study of the hotel to determine its suitability for use as a girls' sanitarium or girls' school. Had it been found suitable for such use, the hotel's history would have taken a very different turn. The hotel has also been a favorite of filmmakers and has been used in several films over the years including the 1971 cult favorite *Vanishing Point*, 1998's *Desert Blue* and the 1987 *Cherry 2000*.

The glory days of the Goldfield Hotel are long gone; once known as the Gem of the Desert and the most opulent hotel in Nevada, today many people consider the hotel to be one of the most haunted places in the state. Recently, Virginia Ridgway, Goldfield Hotel caretaker and historian, appeared on a local television travel show in which she proclaimed it to be "the most haunted hotel in the world."

Whether or not this statement is true, the Goldfield Hotel is an impressive four-story brick building that looms like a specter from a bygone era, a reminder of what Goldfield once was, arousing the curiosity of all who see it.

Quick, ask a ghost investigator what's on his or her bucket list of places to investigate. Chances are the Goldfield Hotel will be somewhere on that list. The hotel is known to ghost hunters far and wide. This has not gone unnoticed by television. Episodes of *Dead Famous*, *Scariest Places on Earth*,

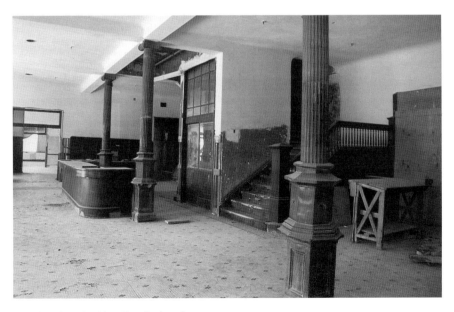

Goldfield Hotel lobby. *Photo by Anne Leong.*

Ghost Adventurers and *TAPS Ghost Hunters* have featured investigations of the building. All have agreed there is something here.

The amount of ghostly phenomena that is said to occur in and around the hotel is staggering. Full-body apparitions have appeared in the basement and at a third-story window; this in itself seems to defy logic. But then again, ghosts aren't confined to keeping their feet firmly on the ground. Numerous people have heard the sound of loud pounding coming from inside the deserted building during daylight hours. Then there are the lights and the sound of tinkling glass, soft laughter and music coming from within the hotel in the wee hours of the morning when it is completely deserted. I personally experienced this phenomenon during a late-night investigation with four friends one summer.

It was one of those sweltering nights that occasionally happen midsummer in the Nevada desert. The air was still, with not so much as a breeze to cool things down. The hotel, which can be bone-chilling cold in the winter, had held the day's three-digit heat and was radiating it through every room. I had come to Goldfield early in the day with my friends Richard St. Clair and Cimarron "Cim" Sam of Empathic Investigations. Set to investigate the hotel with friends Helmey Kramer and Jennifer "Jen" Peterson, we met up with Virginia Ridgway in the hotel lobby and made our plans.

We would begin in the basement, where we hoped it would be cooler. And it was, but only by a degree or two. As we concentrated on filming and recording EVP, Helmey and Jen conducted some experiments they'd planned. Many times during ghost investigations, the cameras are turned elsewhere when something truly amazing happens. So it was on this night. While some orbs are of paranormal nature, for the most part, they have fallen out of favor with ghost hunters. We all watched an orb come from Helmey's hand, roll across a table and disappear into thin air. No, we didn't capture this on film.

Rather than dissipate, the heat clung to the building as the night wore on. After a few hours, we decided that a break and fresh air were in order and headed up the back stairs. As we came up to the area that was once the dining room, we heard people laughing and talking.

"There's people up there," I whispered to the group. We stopped in our tracks. *Someone had broken into the hotel.* What's more, they didn't care if we heard them or not. This sent a chill though us. Ghosts are one thing. But being in a decrepit old hotel with such bold trespassers and the nearest police officers some twenty-seven miles away—now that was downright frightening.

"Our purses," Jen and I whispered simultaneously, "are in the lobby."

Light anomalies outside the Goldfield Hotel at night. *Photo by Anne Leong.*

Helmey, followed by Richard and Cim, went charging up the stairs and into the dining room. No one was there. We knew what we'd heard, so we spent the next hour searching the building and its perimeter. No one but us was about and stirring in Goldfield. Perhaps we had stumbled on a time warp, a long ago party happening again and again within the hotel's walls. Or maybe it was the ghostly inhabitants of the Goldfield Hotel, just wanting to have some fun with us. This experience clearly demonstrates that while we were experienced ghost investigators looking for a haunting, when the phenomenon occurred, we were quick to attribute it to live people rather than dead.

It's unlikely that any of us will ever forget this particular Goldfield Hotel investigation but not simply because of the ghostly party. Don't think that the rest of the investigation was uneventful; it wasn't. There was our sighting of a full-body apparition outside a third-story window. There was also the sound of pacing boot steps that walked down the hallway, down the stairs and then stopped right there in front of us. We separated at one point during the investigation with Helmey and I going to the fourth floor, while Richard, Cim and Jen stayed on the third for an EVP session. While we were on the fourth floor, we heard nothing but silence, while on the third floor, the sound of loud boots pacing up and down the floor was clearly heard. We got some great shots and good EVP, and we considered the investigation a success.

HOT AIR, TALL TALES AND THE MAILBOX IS A BREEZE

There's a Goldfield tale about a jewel thief who made a large haul of jewelry one night. On the run and fearing the law was about to catch up with him, he buried his ill-gotten loot somewhere in the desert between Goldfield and Rhyolite. Diamond brooches, emerald earrings, twenty-four karat bangle bracelets—oh my, it's enough to make you fill up the canteen and dust off the metal detector.

Back in the Goldfield Hotel, legends and lore abound. Of special spine-tingling delight to ghost hunters is the story that the hotel was built atop the town's original cemetery. And wouldn't you know it—according to this tale, not all the bodies were moved before construction began. Adding some sparkle to the story are those who claim to have seen rows of white crosses on the spot where the hotel now stands.

Interesting as this tale is, it's not true. When I asked town historians where the story might have originated, they suggested a film. Apparently, the lot in back of the hotel was decorated with white crosses and used as a cemetery in a

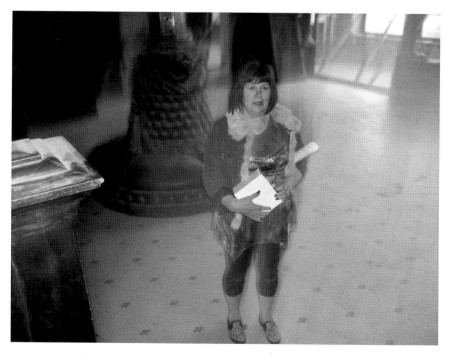

Author surrounded by ghost mist at the Goldfield Hotel during an investigation. *Photo by Bill Oberding.*

movie. There just might be some bodies buried beneath the hotel, but they are most likely canine or feline and not of the *Homo sapiens* sort.

Then there's that underground tunnel that led from the hotel to the red-light district a few blocks away. Nope, there's not a grain of truth to that one either. Another tall tale has it that the lobby ceilings of the hotel were covered in twenty-four karat gold. It's a great story that serves to demonstrate the millions of dollars in gold ore taken from this area, but it's untrue. And so is the tale of Jack Dempsey acting as bouncer for both the Goldfield Hotel and the Mizpah Hotel some twenty-seven miles away in Tonopah.

Among other exaggerated yarns is the claim that Wyatt Earp dealt cards at the Goldfield Hotel. This would have been an impossible feat. The hotel wasn't even built until years after the legendary lawman left town. What is true is that no owner has been able to keep the hotel operating in the black since it was first opened in 1908. The superstitious among us could point to this as proof the hotel is cursed. But that notion is quickly dispelled when we look at how the hotel escaped the terrible fire of 1923. Other than cracked windows from the intense heat of the nearby flames, the hotel was unscathed.

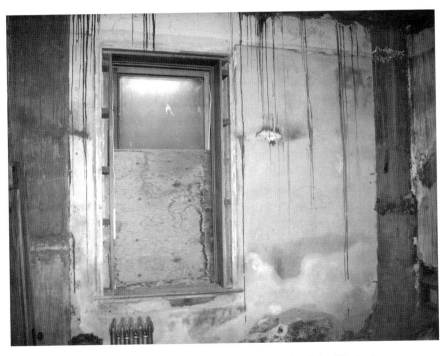

Elizabeth's Room 109. Note the radiator to which some stories claim Elizabeth was chained. *Photo by Bill Oberding.*

About that mailbox: it's possible the strange story got started because the Goldfield Hotel was used as a makeshift post office for a time.

Apparently, a ghost enthusiast who had come to hotel looking for the ghostly Elizabeth discovered that anyone who passes a hand across the mailbox will feel an ice-cold breeze—or so the story goes. Recently, I was at the hotel, and the temperature was soaring well into the nineties. A ghostly cold burst of air sounded like the next best thing to air conditioning and a root beer float, so I tried waving my hand in front of the mailbox several times. Alas, I never felt the promised breeze. This may not have been a very scientific experiment; still, it is interesting to note that the mailbox is located next to the safe at the hotel registration desk, which is not that far from the window to Room 109 (Elizabeth's room).

Virginia and the Moving Flowers in Room 109

Day or night, there is something oddly disconcerting about the Goldfield Hotel that goes beyond ghosts. During the daylight hours, the building has a very different feel to it than it does once the sun goes down. Many people who've visited the hotel only during the day smugly profess it to be "not haunted."

Nothing could be further from the truth. But why argue the point? If only some of the naysayers could explain how Virginia Ridgway manages to move the flowers in room 109…Virginia calls herself a psychic hand healer; her ability has surprised many people who have made their way to Goldfield in search of ghosts. When the feisty octogenarian looks someone in the eye and pronounces what ailment they are suffering from, few deny. In fact, few deny Virginia, period.

Not everyone gains admittance to the Goldfield Hotel. To those few visitors she permits into the Goldfield Hotel, Virginia asks but one thing: bring flowers for the ghostly Elizabeth in Room 109. No one wants to visit Elizabeth empty-handed. Everyone wisely complies, and the flowers, of all colors and types, once placed, are never tossed out. Consequently, flowers in various degrees of decay are strewn around Room 109, tokens of affection to the little ghost whose story is one of sadness and betrayal. Completing the floral mélange are various toys, a teddy bear, mementos from various TV shows and a withering Christmas tree. But the flowers are where the magic begins.

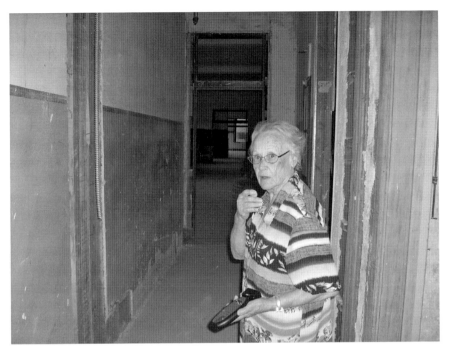

Virginia Ridgway with her Ovilus ghost-hunting device during an investigation of the Goldfield Hotel. *Photo by Bill Oberding.*

When fresh flowers are arranged in a vase in Elizabeth's room, Virginia stands over them and coaxes them to move. In the softest of voices, she asks that they move in accordance to her questions. And amazingly they do. One person who had witnessed this phenomenon said it was as if the flowers were moving to Virginia's voice. There are no wires, no strings and no apparent trickery. So how does she do it? Even she is not quite sure. At Virginia's insistence, others have tried to get the same reaction from the flowers, but all have failed. Those who've witnessed the flowers move believe it is the ghost of Elizabeth, who shows her gratitude by gently moving the flowers for Virginia. And that's as good an explanation as any in the Goldfield Hotel.

Party Ghosts

During its heyday, the Goldfield Hotel offered its clientele a superb first-rate restaurant that could serve over four hundred diners per night. On the menu

The News Building with the Goldfield Hotel in the distance. *The Boomtown Years Special Collections, University Libraries, University of Nevada–Las Vegas.*

were such delicacies as oysters on the half shell, filet mignon and caviar. Night after night, the sounds of tinkling glasses, laughter and music could be heard in the two bars. Imported French champagne and whiskey flowed. Silence didn't come until the sun was up and then it was only until other patrons could wander in and start the festivities all over again. The bars never closed in Goldfield. Here in the Central Nevada desert, in the middle of nowhere, one could meet with friends, relax, forget cares and have a good time.

Apparently, the party continues. An elderly man who regularly drove that stretch of Highway 95 between Reno and Las Vegas shared the following with me:

It was late January, and the weatherman was predicting a light snowfall. I didn't see a problem with that, so I gassed up the rig and headed out of Reno. I was sure that I could make it to Vegas, no problem. Man, was I wrong. By the time I got to Tonopah, it was blowing in all directions. It wasn't sticking, so I continued on. By the time I got to Goldfield, snow was coming down so bad I had to pull off the highway. There wasn't a single hotel in town. "Where was I going to sleep?" I wondered. That's when I turned and reached for my thermos. It was so cold in the cab; a hot cup of coffee was just the ticket. I looked up and couldn't believe my eyes. Down the road, the old hotel was lit up like a Christmas tree. "I must not be the only stranded driver," I chuckled.

The going was slow; it took me about twenty minutes to cover that short distance. I parked the rig, jumped out and got ready to socialize with other travelers. I could hear a piano and laughter, and from the sound of it, they didn't mind being stranded. I was even wondering if they might be offering some kind of food when I walked up to the door.

There was a bolt and a big padlock across the door. I looked inside. The place was dark, and there wasn't a soul in sight. I could still hear them all having a good time.

"Hey, what gives?" I yelled, knocking on the door. "Is that a private party?"

It must have been about ten minutes, and I was shivering there in the snowstorm. "No point in trying to get inside," I thought.

There wasn't any place to stay the night but the local brothel, and they kindly allowed me to sleep there. When I told them about the Goldfield Hotel, one of the girls laughed out loud and said, "That place is so haunted. You're not the first person to hear that party goin' on inside there. It's all those ghosts having themselves a good time."

After that night, I always looked to see if the lights were on when I drove past the hotel. They never were.

An End in Sight

When the doors closed behind the Goldfield Hotel's last paying guests in 1945, the building was locked up and forgotten. Every few years, someone came along and expressed interest in restoring the hotel to its former glory; some of them attempted to do so. But the task proved to be insurmountable.

If anyone was talking about the hotel's ghosts during this time, they weren't doing so publicly. From the late 1960s until the early '70s, an elderly man lived alone in the hotel. Apparently he was acting as the building's caretaker for an out-of-state owner. While in residence, he gave a few newspaper interviews on the hotel and its history. He never mentioned ghosts or the building being haunted. Perhaps he didn't know—or didn't care to know—about such things.

In the early 1980s, Shirley A. (Dybicz) Porter fell under the hotel's spell and purchased it. Her attempts to restore the Goldfield Hotel and her experiences with its ghosts are documented in her book *But You Can't Leave, Shirley*.

Porter's book is chilling. I know that there are some who question the veracity of her book, wondering if it is based on actual experiences or flights of fancy. Regardless of what anyone might think of Porter's book,

the fact remains: the haunting activity she describes has occurred again and again in the Goldfield Hotel. Yes, it's haunted. And if you think the hotel is not haunted, you just might change your mind once you step through the doorway of the Goldfield Hotel.

GEORGE WINGFIELD

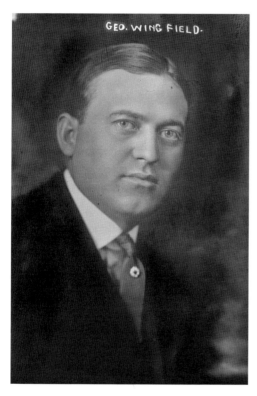

George Wingfield. *Library of Congress.*

Ruthless businessman George Wingfield was not well liked by his contemporaries. He is the most maligned ghost in residence at the hotel, and this, I believe, is one reason he often appears angry. During the early twentieth century, George Wingfield was the most powerful man in the state of Nevada. For all his money and power, George Wingfield has apparently not been able to escape the Goldfield Hotel. His apparition has been seen in the building almost since the moment he died in Reno on Christmas night in 1959. When Goldfield historian Virginia Ridgway witnessed an unexplainable puff of smoke on the third floor one afternoon, she may have been in the company of the spirit of George Wingfield, who is said to either leave ashes or telltale smoke in his wake.

The ghostly Wingfield is usually seen roaming the lobby or standing on the stairs near the hotel desk. Interestingly, the ghost appears not as the youthful George Wingfield but rather as he did later in life, long after he'd put the Goldfield Hotel far behind him. Those who've seen the

specter of Wingfield say that he is smoking a cigar and seems to be very angry and upset.

A young couple who came to one of my Ghost Hunting 101 classes told me the following story:

> *This happened in the fall of 1992 when we were on our way back to Reno. We slowed up in Goldfield and decided to take a look at the hotel. It was late afternoon, and I was looking in through the glass door when I saw this man standing on the stairs across the room. I tapped on the door and tried to get his attention. I figured if we were lucky he just might let us come in and take a peek around. He looked at the door and started walking toward it. "Uh oh," I thought. "He is going to chew us out." He had this angry scowl on his face and a big cigar dangling in the corner of his mouth. Instead of coming to open the door, he suddenly turned in the lobby and headed across the room.*
>
> *He sure was in some kind of hurry. "What on earth," I wondered. "Hey, we heard the place is haunted. We only want to look," I called out. "We aren't robbers or anything."*
>
> *Thinking back, I can say it was one of the strangest things I've ever seen. He walked over toward the big door and was gone. Just like that, he walked right into thin air. I could feel the hairs on the back of my neck standing up.*
>
> *Later, I told some friends, and they said it was the ghost of George Wingfield who was stuck at the hotel because he had murdered a girl in room 109. Whoever he was, he didn't look like a very nice person to me.*

ELIZABETH, THE GHOST IN ROOM 109

Did Elizabeth exist? Or was she simply the product of overactive imaginations? Many historians and ghost researchers doubt the validity of the entire Elizabeth-in-Room-109 story. Nonetheless, her ghost has become synonymous with the hotel. Her poignant story is the most often repeated in connection with the hotel's hauntings.

There are several different versions of the tragic tale of love and betrayal that begins in 1908, shortly after the hotel was completed. There are those who say the affair between Elizabeth and the wealthy George Wingfield took place much later. They put the story at some time during the 1930s.

If anyone would know about the Elizabeth story, it would be Virginia Ridgway, who has been caretaker of the hotel for over thirty years. When asked, Virginia said, "None of the psychics I have taken into the hotel in the past thirty years has ever told the Elizabeth story. None have ever claimed that the child was killed. They all describe the same thing. A young girl with long blonde hair...She is chained to a bed and there's her little belly."

Who can say when or where the tale got its start? Because it is the most often told of the hotel's ghostly legends, I've included it.

The favored version takes place in 1908. Like thousands of others who came to this desert city during its 1903 gold rush, Elizabeth dreamed of untold riches. At the very least, she hoped that her beauty might ensure marriage to a wealthy man.

But jobs were not that plentiful, especially for a woman. Rather than beg or go hungry, Elizabeth went to work in the city's red-light district. Certainly, this was not the sort of job one told her family about, but it kept starvation at bay. There was always the possibility of being lucky enough to snag a man of means, marry him and move into more respectable circles.

Perhaps Elizabeth thought she had found just such a man for herself when she caught the eye of George Wingfield. Not only was he rich beyond her wildest dreams, but she also thought him one of the most handsome men in town. According to a long-told local legend, Wingfield was so smitten with the lovely young prostitute that he moved her into Room 109 of the Goldfield Hotel. Wingfield may have been infatuated, but the astute businessman had no intentions of marrying a woman like Elizabeth. His power and wealth were steadily increasing; he had moved from his rough circle of gambling friends and was beginning to associate with a more refined group of men. Marriage to a prostitute would not be advantageous to him. If she realized that Wingfield wasn't going to marry her, Elizabeth wisely never let on. When he married another woman, she finally saw the truth. Her lover had never considered her worthy of being his wife. Hurt and angry, Elizabeth waited for Wingfield to visit her in Room 109 and then sprung her news: she was pregnant with his child. What would his wife say? More importantly, what would become of his carefully cultivated friendships with Goldfield's elite upper class? Enraged, Wingfield made a terrible decision. He would keep Elizabeth prisoner there in Room 109 and starve her to death.

Another bizarre version of the story has Wingfield chaining the hapless young woman to the radiator and choking her to death. Yet another has her giving birth only to see her child murdered in cold blood by Wingfield, who later killed Elizabeth as well.

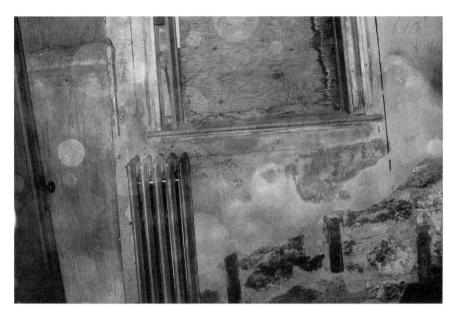

Room 109 with orbs. *Photo by Sharon Leong.*

Even if there were any truth to these stories regarding how and why the ghostly Elizabeth came to haunt Room 109, it is highly doubtful that George Wingfield was the culprit. With plenty of money and power at his disposal, Wingfield could easily have paid others to do his dirty work; for that matter, he could even have paid Elizabeth to leave the city.

George Wingfield's name may have come to be associated with that of the ghostly Elizabeth because of his common-law wife, Mae Barric. At a divorce hearing in which she sought support from Wingfield, Barric accused him of verbally and physically abusing her. Certainly, these aren't stellar qualities; perhaps it was his very behavior toward Barric that indicates how Wingfield might have handled the problem of a pregnant prostitute. In the days before DNA testing, and given Wingfield's power, there is no doubt that his denial would have been all that was necessary to sway public opinion.

For argument's sake, let's assume for a moment that a young woman was held against her will in Room 109; who was her captor, and why did he hold her prisoner? The rooms on the first floor were generally kept for hotel employees' use, so it's very possible that the captor was either an employee of the Goldfield Hotel or an owner—and that brings us back to George Wingfield, who owned the hotel from 1908 until 1923.

But Wingfield was a popular man about town. Too many eyes were on his every move. It would have been risky, even for him, to have kept a secret like Elizabeth in Room 109. The captor was, in all probability, an employee of the hotel. But why didn't Elizabeth scream for help?

The room is located near the billiard parlor, a very popular area in the hotel's early days. Building standards of the early twentieth century were not what they are today. The inside walls of the hotel probably didn't have much insulation. If Elizabeth had screamed, someone might have heard her. Why didn't she try to summon help? There are a number of reasons; perhaps she wasn't a prostitute but an errant wife. When her husband discovered that he had been cuckolded, he might have kept her prisoner in the room until—and if—his anger subsided. Given the social mores of the early twentieth century, his co-workers may have thought that he was well within his rights to deal with his wife in such a way.

Keeping her quiet would have been easy. By regularly administering morphine or opium to his prisoner, Elizabeth's captor could have ensured her complacency and her silence.

Was a young woman held against her will in this room so long ago? Is there any truth to the story of Elizabeth? Or is it merely a story told to explain the strange occurrences that go on in Room 109?

There is no denying that there is paranormal activity in Room 109. Too many witnesses have seen the ghostly young woman, known as Elizabeth, in the room or walking in the front hallway. Clad in a long white nightgown, the beautiful apparition seems to be searching for something. Perhaps it is her child who was so cruelly taken from her.

Would Wingfield—or anyone one else—have risked it all by keeping a woman chained up in such a public place? According to one story, Wingfield was angry with the young woman and kept her chained in one of the rooms until she and her unborn child died of starvation. For this terribly heartless act, the ghost seems to have no remorse. Those who've felt his icy presence can also sense his anger and hostility. He is said to roam the hotel freely, particularly the lobby and the staircase.

His victim has also been seen a few times, cowering in the room where she died. There is a heartbreaking sadness about her. Perhaps the pitiful ghost is still seeking justice and attempting to point out her murderer.

Some people tell the story as having happened in the 1930s rather than 1908. Other than the era when it took place, the tale is basically the same bizarre scenario. Wingfield was infatuated with a young prostitute and for whatever reason kept her hostage in room 109 where she eventually died.

By the 1930s, Goldfield's boom was over and the population had dwindled. George Wingfield was living in Reno and dealing with the failure of his banks.

THE STABBING GHOST

He's known as the Stabbing Ghost. He may be a ghostly actor who still plays the part of the villain, or maybe he is the ghost of a long-ago Goldfield man who stabbed his wife to death. Most likely, he is only someone who feels protective of the Goldfield Hotel. Whoever he is, the Stabbing Ghost has never hurt anyone. But this isn't to say that he doesn't frighten anyone he encounters—he does. Those who have seen him say the Stabbing Ghost is terrifying as he raises his hand and stabs away with his ghostly knife.

Unlike Elizabeth, the stabber is not associated with the earliest days of the hotel but is believed to have come to the premises decades later. Some who are sensitive to such ghostly activity usually see the stabbing ghost in what was once called the Gold Room (the dining room) of the hotel. I have

The Goldfield Hotel during an investigation. *Photo by Anne Leong.*

Virginia Ridgway, Robert Allen and the author during a break in the Goldfield Hotel dining room. *Photo by Bill Oberding.*

been in the area he haunts numerous times and have yet to encounter this particular spirit (thank goodness).

That said, one evening I was in the dining room alone, and at the farthest corner of the room, I turned my recorder on. On playback later, I discovered that I had recorded an angry man's voice. He wasn't afraid to tell me just what he thought of ghost hunters in the vilest words imaginable.

Even though they might not have seen him, several ghost investigators say the Stabbing Ghost is to blame for the headaches and backaches they've experienced while in the hotel.

DEAD FAMOUS SÉANCE AT THE GOLDFIELD HOTEL

Ghosts are timeless; ghost hunters and the understanding of the paranormal are not. How we perceive the paranormal (hauntings, particularly) has changed. What was presented as credible evidence of the existence of ghosts

a few years ago is scoffed at today. The appearance of orbs in early digital camera photographs is an example. Those who seek ghosts today are far less naïve than those in the early 1900s. As an example, I believe that Sir Arthur Conan Doyle was a brilliant man. He was also a believer in the paranormal who regularly attended séances. Yet he was duped by two young girls who convinced him that they had actually photographed tiny fairies. No one in the twenty-first century would believe this after looking at the girls' so-called fairy photograph, which turned out to be a hoax. Also a new phenomenon since TV are the ghost-hunting teams, groups of people that go ghost hunting. Then there is the thing that so many ghost hunters joke about: a number of people actually see ghost hunting as a stepping stone, a way to become famous and to achieve stardom with their own TV show. Where the paranormal was once frightening to most people, TV has helped to move it more toward the mainstream.

Investigation of the paranormal, and this includes ghost hunting and TV shows, has changed significantly since that evening several years ago when I first met the *Dead Famous* crew at the Polo Lounge in Reno. The segment we were to do was on Frank Sinatra's Cal Neva Lodge at Lake Tahoe. After doing two Thunderbird Lodge segments with this particular group, I knew that I would work with them whenever the opportunity presented

The Goldfield Hotel stairs. *Photo by Anne Leong.*

itself. The show's two stars, Chris Fleming and Gail Porter, were charming, unpretentious and easy to work with. When they called and asked if I wanted to take part in a segment at the Goldfield Hotel, I readily agreed.

And yes, I was told, I could invite a few ghost-hunting friends as well. Once again, Virginia Ridgway was waiting for us at the hotel. She had finished her interview and was ready to visit. While Gail and Chris did a preliminary investigation of the hotel, Virginia and I chatted about ghosts and history and waited for it to get dark. Chris was going to conduct a séance in which Virginia and several of our ghost-hunting friends would take part. As the skeptic parapsychologist, I was to sit on the sidelines with Gail and observe the action.

The location we chose for the séance was in the lobby at the foot of the stairs where George Wingfield's ghost is most often spotted. As the last streak of daylight faded, Chris lit a candle in the center of the circle. The other sitters eagerly took their places in the circle; Gail and I sat on the stairs, and the cameramen maneuvered around the group.

Chris instructed everyone to join hands, and it was ACTION. Almost instantly, Chris appeared to be overcome by a spirit that spoke in a singsong voice. Could it be Howard Hughes? I remembered hearing something about Hughes having spent time here at the old Goldfield Hotel. And as I listened to this rather stilted monologue, I wondered if there was any truth to the story. Can't be, I decided. Surely Hughes has better things to do in the great beyond than to come here to the Goldfield Hotel and admonish this assemblage, I told myself. Or does he? In life, he spent a great deal of time here in Central Nevada. He married Jean Peters in Tonopah and visited the Cottontail Ranch brothel near Lida Junction. And then there's the story of Melvin Dummar, who claims to have given Hughes a ride on Highway 95. Just possibly, Hughes had broken away from the hereafter to come to the Goldfield Hotel and spend some time with us.

Howard Hughes or not, the spirit was gone as swiftly as he had come. The room was silent, and according to a friend who sat in the circle, Chris's hand felt like electricity was surging through it. A few of the sitters seem to be drifting into a dreamlike state. Not so for one man who suddenly spoke in an angry formal voice. His inflection was completely different than his normal mile-a-minute style of speaking. Was this George Wingfield, we wondered?

He was angry and wanted to argue. Chris refused to do so. Instead. he spoke calmly, but firmly. The spirit continued to taunt him.

Virginia was overcome with emotion and began to weep. At that moment, some felt that she was channeling the ghost of Elizabeth.

The author during EVP session at the Goldfield Hotel. *Photo by Bill Oberding.*

"They've killed my child," she wept softly. Chris comforted the spirit and urged both her and the strange man who spoke through my friend to go toward the light.

Later, one of the people taking part in the séance said she saw two blue lights lift from the circle and rise toward the ceiling when Chris urged the spirits onward.

A lot of this was never shown on television. As with all such shows, time constraints don't allow for everything to be shown. Consequently, much of the séance was edited out. In my opinion, they took out some of the most interesting portions of that particular night at the Goldfield Hotel.

After the segment wrapped up, Virginia graciously permitted us to conduct another investigation of the hotel. We took photographs and recorded EVP, and as we walked down the fourth-floor hallway, we discovered a dead bird that had somehow got trapped in the building. As we stopped to ponder the bird's unfortunate ending, the sound of laughter and music was coming from one of the rooms at the other end of the hallway.

A dead pigeon inside Goldfield Hotel. *Photo by Sharon Leong.*

There was certainly a party going on. We crept closer to the room; the sounds grew dimmer and ceased altogether. Perhaps we had encountered a different dimension, some sort of time warp or a ghostly party to which we weren't invited. Some paranormal researchers have long believed that the Goldfield Hotel is one of seven portals to the other side—or to Hell, take your pick. This might explain how one moment we heard gaiety and laughter, and the next there was nothing but silence.

PANCAKE BREAKFAST AND DID YOU KNOW THIS PLACE IS HAUNTED?

This story could easily be put in the Goldfield section, but since it occurred after the *Dead Famous* séance and investigation, I have placed it here.

The people of Goldfield and Tonopah are proud of the place of their towns in Nevada's history, and two big events celebrate this. Tonopah's Jim Butler Days (on Memorial Day weekend) honor Jim Butler and his silver discovery that led to Nevada's twentieth-century silver boom. It's a fun-filled weekend of arts and crafts, car shows, street dances and arm wrestling and other contests. Goldfield Days is Goldfield's big event (in early August) that

showcases the arts, crafts and history of the town. The people of both towns are friendly. This is especially true of the towns' elected officials.

When news got out in Goldfield (and you know that was faster than the speeding bullet) that a British film company was in town shooting a TV show, some of those who held public office wanted to welcome the Brits. Only a couple of the crew members were actually her majesty's subjects, but it didn't matter. All of us who had worked on the TV shoot were invited to a pancake breakfast at the community center the morning after filming. Can you imagine the city officials of Las Vegas, New York or any large city rolling out the red carpet for a small film crew focused on ghosts? Neither can I. But this is Goldfield.

The breakfast was to be served at the community center, an old church, complete with a beautiful stained-glass window, that seats about one hundred. There weren't one hundred of us, however; just a couple banquet tables, and we were set to be served our pancake breakfast of pancakes, syrup and coffee. After introductions all around, we were given an informal talk on the town, its history and not-to-be-missed sights. Then it was our turn to share the details of the previous night's ghost hunt at the Goldfield Hotel. Had we run into the ghost of George Wingfield or Elizabeth?

Details shared and breakfast over with, a couple of us stayed behind to help with the cleanup. That is when one of the women who'd helped with the meal asked if we were psychic enough to realize the community center was haunted. Did we sense a spirit? She explained that this was a nice spirit, nothing like the mean ones who resided down at the hotel, and she asked if we could tell her more particulars. We tried but didn't sense anything, good or bad.

Years later, I remembered the incident when Virginia and I did a small ghost conference at the community center. The lectures were concluded when a middle-aged woman walked in. She told us she was passing through on her way to Las Vegas when she noticed people coming and going, so she stopped. She'd always wanted to see the inside of the building. As Virginia showed her around, she told us that she was a psychic and that she loved Goldfield.

"Do you feel the building is haunted?" I asked.

"Oh, yes," she smiled. "There are two ghosts here. I believe they are sisters, although they could be mother and daughter."

Name, dates and other details eluded her. But not to worry, these spirits are friendly and won't bother anyone.

Is There a Child on the Third Floor?

On an unseasonably warm spring night, twelve ghost hunters were geared up and ready to investigate the third floor. Aside from the heat and the dust, nothing remarkable was happening. Then one of the women jumped. "Did you feel that?" she asked the group.

All cameras and meters swung her way. None of the others had felt a thing.

"Something brushed my arm. I think it's a little boy," she insisted.

"There is supposed to be a child's ghost on this floor," someone whispered.

"Oh my goodness, it is a little boy," a woman said. One by one, the group began to feel the presence of a child. Someone rolled a ball across the hallway, saying, "Let's see if the ghost will roll it back."

The ball didn't move, yet everyone was feeling the presence of a ghostly child. The ball moved a centimeter.

"Didya see that? Didya see that?" someone yelled. Then a man held up his EMF meter, one of those with the big red light on the end of it. He wanted to use his meter to play the old "blink once for yes, twice for no" game

The Goldfield Hotel Lobby. *Photo by Sharon Leong.*

with the ghost. This investigation quickly disintegrated into a question-and-answer session using an EMF meter.

"Are you a boy? Blink the red light once for yes and twice for no."

The meter blinked once.

"Are you happy?"

The meter blinked twice.

"Can we help you?"

The meter blinked a dozen times.

"That means no, you can't. Now get the hell outta here," someone joked.

Undeterred, the group members continued asking questions. Having heard the tale of evil ghostly midgets that roam this floor, I doubted that the investigators were communicating with a child. Thinking this could easily turn negative, I wanted no part of it, so, leaving them to their "ghostly interview," I went downstairs to the lobby.

It was hot and I was thirsty. I dug in the ice chest and pulled out a can of diet cola. As I gulped the soda, something brushed against the back of my leg, much the way a cat might do.

"Okay, who's the jokester?" I asked, whirling around to discover that I was all alone in the lobby. Not a ghostly kid and probably not George Wingfield, the stabbing ghost or Elizabeth—so who?

"I know you're not a child," I said to whoever, or whatever, it might have been. If I had to guess, I would have said it was a cat. That's exactly what it felt like, a cat brushing itself against me. I made a note to myself that I would have to remember to check and see if there are any reports of ghostly felines walking the halls of the Goldfield Hotel.

Later that night, I asked Virginia about any ghost cats, and she said, "In 1979, Shirley Porter found a dead cat under the stairs."

In *But You Can't Leave, Shirley*, Porter tells of finding what she assumed to be the bones of a dog under the stairs. She also describes the sudden illness and death of one of her cats. Could this explain a ghostly cat? If there isn't a cat from the hereafter on the premises, there is something else that makes itself known by brushing up against people.

WHO'S STOMPING?

Ghosts are especially popular at Halloween, especially with the news media, which waits all year long to spring haunted houses and ghosts on the news-

watching public. In their quest, they're always in search of some exciting venue, the creepier the better.

A few years ago, I was asked to accompany a local television crew and a team of paranormal investigators to the Goldfield Hotel, where we were to tape a Halloween special. As the sun burned overhead, we explored the hotel, took photographs and made our plan of attack. At dusk, we headed to the diner. Do you doubt that we talked ghosts, specifically those who reside in the Goldfield hotel?

Of special interest was the who and the why of the hotel's hauntings. While we agreed that Room 109 is haunted, we questioned the story of Elizabeth chained to the radiator. Then too, we wondered if the ghostly George Wingfield is still roaming the premises. The so-called portal or vortex? Opinions were evenly divided.

Then dinner was over. It was dark, and we were in the mood for ghost hunting. One of the crew members was apprehensive. It was her first ghost investigation, but she'd heard plenty of stories. So there we were, six of us on the fourth floor. All was quiet as we crept in and out of the rooms along the darkened hallway. We spoke in whispers as we introduced ourselves and coaxed the hotel's unseen residents to speak to us: "Say anything; just let us know that you're here. We mean you no disrespect." Our EVP session was abruptly ended by loud banging; someone was stomping heavily up the stairs.

"Hello?" the journalist called. "Do you mind? We are taping up here."

No answer. Who would be so rude as to disturb our taping? More importantly, how had he or she gotten past Virginia Ridgway, who was patiently waiting for us on the sofa in the lobby downstairs? Anyone who knows anything about the hotel knows how sound carries throughout the building; if this person didn't, he or she was about to find out.

We crept over to the staircase and shined our flashlights on the stairs. No one was there. Enthused about EVP, the journalist told his soundman and cameraman to play the tape back so we could hear the banging again. Perhaps there would be some EVP along with the banging.

They carefully rewound the tapes. We all listened in stunned silence. Except for our whispered comments, there was nothing. None of the stomping and banging we had heard was on the tapes at playback. When Virginia was asked about it later, she said that she hadn't heard any loud banging or stomping, and certainly no person had gotten past her at the sofa—no living person, that is.

THE *SCARIEST PLACES ON EARTH* INVESTIGATION

In 2001, before television ghosts and ghost shows became en vogue, I was contacted by the producers of the television show *Scariest Places on Earth*. They wanted to know what I thought was the scariest, most haunted building in the state of Nevada. There was no question in my mind; it had to be the Goldfield Hotel. I agreed to be involved with an all-night investigation, and within the week, my husband and I were headed to Goldfield.

Virginia Ridgway was contacted, and thankfully she agreed to be to take part in the filming. Once there, we met up with the feisty Virginia and our team members and discovered that the show had also brought along a psychic, two ghost town enthusiasts and their dog Ripley, an adorable black lab. The theory that animals are sensitive to ghosts would be tested tonight.

We stood outside, talking about the hotel, ghosts and how anxious we were to get inside. For our troubles, we were permitted a cursory look inside the building. After a few photographs, we were told that we would have to wait until it was dark to go back inside. And so we waited…and waited…

Finally, the sun was setting, and the light was right. The director decided we could at last enter the hotel. But something wasn't right, so we started in again. She was not satisfied this time either, however.

"Cut!" she yelled.

We gathered on the steps once more. On the director's command, we all entered. This was not a good entrance either. It had been a long, hot day, and we were eager to get back into the hotel. Feelings were tense. No one was happy at having to do "the scene" over and over.

"I'm a ghost investigator, not an actor!" one of the investigators snapped.

The director ignored her. We were working gratis. Other than the opportunity to go inside the old building, we were being paid nothing. After four attempts at the perfect entrance, the director was pleased, and we entered the darkened Goldfield Hotel. The place was creepy, dusty and dirty. There was a distinct feeling of something all around us. Others were aware and commented on it as well. Was it mass hysteria, the excitement of being in the old hotel or imaginations running full-speed ahead?

As I walked to the corner of one of the downstairs rooms (which turned out to be Room 109, Elizabeth's room), I felt unmistakable pressure on my head. A feeling of being compressed came over me. I moved from the corner and tried to take a photograph. But as they often do in such circumstances, the camera didn't work.

The TAPS van at the Goldfield Hotel. *Photo by Bill Oberding.*

Meter readings were high in this area. Not only were the cameras failing, but our flashlights dimmed intermittently as well. My husband's watch gave strange, sporadic readings on its barometer.

It is said that animals are more sensitive than humans. For whatever reason, Ripley did not want to be in the Goldfield Hotel. She balked when she was taken upstairs with us, becoming more frightened with each step. On the third floor, she stopped at the doorway of a room and refused to enter. No amount of coaxing could persuade her to go in. Could this be one of the rooms where a suicide took place so long ago? Whatever it was, Ripley didn't like it and wanted no part of this room.

The dog was not being a canine prima donna, only cautious. Suddenly, one of the investigators was overcome with sorrow. For no apparent reason, she started sobbing uncontrollably, her very ample chest heaving with each sob. The director ordered the cameraman to catch the action on tape. He did—and it is something we still laugh about. The resulting scene is not one of her anguish and pain but rather of her rather large bust bobbing up and down. Ah, for the days of less slick television, when reality TV was still in its infancy.

The author with Zak Bagans during filming of the Goldfield episode of *Ghost Adventures*.
Photo by Bill Oberding.

While I might doubt the story of the ghostly murdered prostitute Elizabeth and her child, I believe that there is something paranormal here.

Shortly after this filming, Red Roberts purchased the Goldfield Hotel and has since permitted *Ghost Adventures* and *TAPS Ghost Hunters* to conduct investigations. In the *Ghost Adventures* episode, Zak Bagans had a brick thrown at him in the basement. The footage is compelling, some of the most startling evidence to come out of the Goldfield Hotel.

Séance in Room 109

The sun was shining brightly, and the temperature was a sweltering ninety-plus degrees when we gathered in a circle in Elizabeth's room and prepared to conduct the séance.

This was not the first séance to be conducted here at the hotel, and surely it won't be the last. Getting in touch with the dead is not a new idea. Séances

have been conducted since the early 1800s. While there may be nothing in the way of scientific evidence that can be gathered during a séance, we felt that it was one way to contact the spirit known as Elizabeth who is said to reside here in Room 109. And so we began. A chill swept through the room as we joined hands and called for Elizabeth.

"Elizabeth had a secret," the words tumbled through my mind. Out loud, I asked, "Does anyone know about Elizabeth's secret?"

The man sitting across from me nodded and said, "I believe that—"

He stopped and touched his throat. "It felt like someone was grasping my throat," he said.

"She doesn't want anyone to talk about her secret," another person admonished us.

But I know the secret, and I saw it as clearly as I saw the shadows flitting across the wall in this room, which is darker than any of the other rooms because its window opens onto another room rather than outside. "Dare I say aloud what I believe happened here in Room 109 so long ago?" I wondered. I chose to keep quiet.

"My head hurts," someone said. "It's like she's applying pressure to my temples."

"Elizabeth, we mean you no harm."

By now, our eyes had adjusted to the room's darkness. Someone screamed about movement in the open closet. It was a shadow that quickly vanished.

When the séance concluded, one of the women rushed up to me. "I know what her secret is," she announced gleefully. "She killed her own child. Yes! She gave birth here in this room but didn't want the baby. It was a boy, you know. And she tossed him down the mineshaft in the basement. She was so ashamed of what she had done that it drove her crazy. They had to keep her chained up—oh, but not here in Room 109. She comes here because this is where she met her lover, the father of her child."

I nodded. She had seen the same thing I had seen. Were we right, or had our imaginations taken flight and somehow wandered down the same path?

SUICIDE AND THE AROMA OF LILACS

Faith, the ghost at Prescott Arizona's Hassayampa Inn, who hanged herself when her husband went out to buy cigarettes and never returned, has a story similar to that of the ghostly young woman on the second

Virginia Ridgway and the author during an investigation of the Goldfield Hotel. *Photo by Bill Oberding.*

floor of the Goldfield Hotel. Alone and abandoned, the Goldfield woman waited several days in the hotel before hanging herself in despair. Now she spends her time hoping for his return and wandering the second floor of the hotel. Forget howling and moaning—you will know she is near by the aroma of lilacs that always precedes her presence. This is not so unusual; ghosts often announce themselves through scent. The aroma of flowers, cigar smoke and apples are some common scents associated with ghostly activity.

This ghostly young woman likes to show how much she likes certain people by spritzing them with the heavy scent of lilacs. Hopefully those given this honor aren't allergic, or this can be a most uncomfortable experience. Apparently she really liked sensitive Chris Fleming. During filming of a *Dead Famous* episode at the hotel, he was sprayed with so much of the ethereal perfume that his eyes watered. I have experienced other investigations at the hotel in which the aroma of lilacs was so strong that it permeated the air as if someone opened a bottle of perfume and sprayed all its contents into the air. The ghostly woman's treatment of Chris was like that.

If she dislikes someone, the ghostly young woman merely ignores him or her. When she isn't dousing a favored person with perfume, the spirit likes to announce herself by a rush of cold air or a wispy touch on the back of the neck.

HONEYMOONING *TITANIC* GHOSTS

I had always thought of the ghosts of the Goldfield Hotel as early Nevadans, the men and women who lived, worked and died here in Central Nevada. When I first heard about the *Titanic* ghosts of the Goldfield, I was skeptical. But given that ghosts can, and do, go wherever they so choose, I had to ask myself, "Why not?"

While I agree that there are some very negative and downright hateful ghosts in residence at the Goldfield Hotel, I realize they aren't all negative. To those who would argue that there is nothing but negative spirits residing here at the hotel, I offer the *Titanic* ghosts.

It was Good Friday, April 5, 1912, when the unsinkable *Titanic* left port on its maiden voyage. Nine days later, the ship hit an iceberg and sank in the Atlantic Ocean thousands of miles from the Goldfield Hotel. The disaster claimed 1,517 lives. Among those who perished was a honeymooning couple who haunt a room and the hallway of the hotel's second floor—at least this is what several psychics who have visited the hotel claim. But why would this couple choose to haunt the Goldfield Hotel in the middle of the Nevada desert?

During a séance, the ghostly young wife explained their reasons. The Goldfield Hotel was known worldwide for its elegance. She and her new husband came west to Nevada especially to spend a few nights at the new hotel before resuming their long journey that would eventually take them to Southampton, England, where they would board the luxurious *Titanic*.

The newlyweds have been seen on the second floor by several psychics. When spotted in the hallway, they are described as happily walking arm in arm. He is attired in an elegant black evening suit, and she wears a full-length sky blue and pink satin dress. When they are seen in that certain room, the happy couple is gazing out the window at something in the long-ago distance. Apparently they enjoyed their short stay at the Goldfield so much that they decided to come back and experience the honeymoon euphoria indefinitely. It has been said that love conquers all; perhaps in this young couple's case, love has even conquered death.

Voice on the Third Floor

It's well known among those who investigate ghosts that they sometimes play tricks on those who are trying to gather evidence of their existence. This is especially true here at the Goldfield Hotel. The brick that was thrown at Zak Bagans and Nick Groff during filming of their documentary is an example. Another example is disembodied voices that seem to change locations.

This was a similar case of trickery. It was somewhere between spring and summer, before the weather warmed up enough to really enjoy a ghost investigation. That mattered little. We were bundled up and ready to go. There were ten of us, so we split into two groups and began our quest on the second and third floors.

Those of us on the third floor split up and went to different sections of the hall. It was so dark in there; even with a flashlight to guide us, it would have been easy to get turned around and lost. As we walked along, we recorded and asked the usual questions. Minutes passed, and eventually we all came back together as a group—all but one person, that is.

We could hear her at the end of the hall chatting away. Apparently, she was recording EVP. When she stopped talking, we called out to her, "Is that you, Geri?"

"Yes, it's me," she replied.

"Stay there, we're coming."

"Okay," she chuckled.

We turned and walked toward the end of the hall and Geri. When we got there, she was nowhere to be seen.

"Very funny!" someone in our group said.

At that moment, the sound of footsteps on the stairs echoed through the hallway, and there was Geri, coming up from the second floor.

"How did you get down and back so fast?" we asked.

"I was at the car," Geri replied.

"We just heard you a minute ago here in this room."

"Not me, you didn't. I've been in the car trying to find that new set of batteries," Geri said calmly.

WHO FRIGHTENED VIRGINIA?

As its caretaker for the past forty years, Virginia Ridgway has been in the Goldfield Hotel hundreds of times. A psychic, Virginia has communicated with the old hotel's ghosts and conducted séances in the building. She was never afraid of the hotel or any of its resident ghosts—until one February night.

It was the dead of winter. The hotel was so cold that icicles hung from walls in the basement. Before they got their big break that would propel them to instant paranormal stardom, the *Ghost Adventures* team (Zak Bagans, Nick Groff and Aaron Goodwin) had come to town to conduct a two-night investigation of the hotel. Virginia, having guested in their award-winning documentary, was naturally in attendance. Bundled up against the cold in coats, mittens and boots, she spoke softly to the spirits while the shivering participants recorded EVP and took photos. The night was progressing well until about midnight. Up on the fourth floor, Zak had decided we should conduct an experiment in which everyone would record EVP at the same time.

For the group recording session, Virginia and I chose a room at the end of the long hallway. While Zak and the guys did their signature provoking of the spirits, Virginia stood watching silently in the doorway. She has never approved of provoking and doesn't mind telling anyone so. Suddenly she tensed up. "Look! Do you see that?" she asked, pointing to the dark hallway. I looked, rubbed my eyes and stared. I saw what appeared to be two blobs of darkness slowly rolling toward us.

I turned to Virginia and saw the fear on her face. Stepping behind me, she whispered, "They want me."
I had sensed this as well, hence my lack of trepidation. But clearly Virginia was afraid. In all the years I have known this spunky lady, I had never seen her so shaken. Later, we discussed it at length. Both of us instinctively realized whatever or whoever it was wanted Virginia. As we talked this incident over, we decided that the ghosts who reside in the hotel may have been upset at Virginia because of the provoking style of ghost hunting that went on during that investigation. Virginia has since explained to the spirits that she had no part in the incidents and did not encourage or want any provoking to go on in the hotel and that she would never permit it to happen again.

What is provoking, you ask? Provoking is the old my-dad's-stronger-than-your-dad routine; it's taunting or challenging the unknown so that an

investigation will yield results such as credible EVP or photographs. Most people now believe provoking is wrong, and the practice has been all but abandoned. Besides that, you never know who or what might take up your challenge, and that could bring disastrous results.

SPARKLES

A friend who has investigated the Goldfield Hotel numerous times told me the following:

Have you ever noticed that there's more energy on the right side of building? When you're facing away from the highway…I felt that right away. I asked someone else, and she agreed with me. In the basement I was told that there were sparkles all around me; I didn't see them. Anyway, that basement is creepy! There's something there. I did see something. I'm not sure which floor we were on; it may have been the fourth. We were in the room that had three dead pigeons lined up, and I was talking with Aaron [*Ghost Adventure's* Aaron Goodwin]. He's a nice guy. I walked out of the room and was standing there by myself when I saw this ghost in the hallway.

I've heard about Tex, [but] this wasn't him. This was a young man about sixteen to eighteen, not any older than twenty. He was a working guy with dark wavy hair, and he was wearing coveralls. I didn't know if it was my imagination or not. I looked down and looked back up, and he was still there. His eyes were black and blank. He had this really white skin like a dead person. You know, when the blood stops perfusing [and] the skin gets this grayish color…I'm a nurse; I've seen dead people. He was dead. I turned and ran and bumped into my friend.

She took one look at me and said, "Let's get out of here." I asked her why she said that.

"I've never seen you look like that," she said.

I guess it must have shown on my face how frightened I was. Later I was sitting there in the hallway. I closed my eyes and was being very still and very quiet. I felt like something was trying to get into my body. A force or whatever…I've never had that happen to me. I heard a lady scream. It was an otherworldly scream. In some ways I'm frightened to go back in there. I get chills just talking about it.

WATCHER IN THE BASEMENT

Another friend who has investigated numerous locations throughout the country reported feelings of apprehension and of being watched while in the basement of the Goldfield Hotel. She said, "It's like a maze down there. The time we were investigating there, I got so turned around. I just couldn't shake this feeling of uneasiness and like someone was watching me. I know people say it's the fourth floor, but I think most of the activity is there in the basement. Something probably happened down there a long time ago."

I had my own experience in the basement with a long-haired man who wore a black leather jacket and jeans. I didn't know everyone in the group that night and only noticed him because he was standing too close to me, invading my personal space, actually. I looked at a friend who was there with me, as if to ask, "What is this guy's problem?"

When I turned back toward him, the man was gone.

"Did you see that?" I asked my friend.

"What?" she asked.

"The man who was standing right next to me," I replied.

"There was no one by you."

"I saw him!"

"Well, I didn't," she laughed.

WHO SHOT CURLY FENNEL?

I believe that Curly Fennel is one of the ghosts in residence at the Goldfield Hotel. After researching his death in the building, I think he haunts the hotel not necessarily because he died there but because his death occurred under strange circumstances. Perhaps he badly wants to tell his side of what happened on that long-ago morning of July 9, 1925.

The sun wasn't yet up when the clock jangled Mr. and Mrs. James "Curly" P. Fennell awake. In another part of the country, the second day of the Scopes trial was underway. Schoolteacher John Scopes stood accused of teaching evolution. Defending him was one of the most famous attorneys of his time, Clarence Darrow. The prosecution was headed by the no less famous William Jennings Bryan. The Scopes case had captured national attention, and newspaper writers and radio newscasters made sure the public was well informed about the goings-on at the Rhea County

Courthouse in Dayton, Tennessee. But here in Goldfield, Nevada, James Fennel had another trial on his mind.

He was under subpoena to give testimony in a $30,000 Sparks bank robbery, and there was no way out of it. He eased up on one elbow. What was the hurry? They had Boyle dead to rights in the Sparks jail. There were too many witnesses, the fool; still, $30,000 might make a man do a lot of things he wouldn't ordinarily do.

Fennel looked at his jacket. He didn't have anywhere near that amount of money. But he had his own grubstake. And he was all set to start his own business here in Goldfield with the $1,700 cashier's check in his pocket.

If he could change anything, he wouldn't have been such a Good Samaritan. He certainly wouldn't have given Boyle a ride across the desert into Beatty. If only the foolish Boyle hadn't spilled the beans to him. Now he was caught right in the middle of it, and that was an uncomfortable spot to be in. He had already given a statement to the police; they knew that he would give his testimony when he arrived back in Sparks. With all the eyewitnesses, he couldn't understand why they needed him anyway.

Mrs. Fennel jumped out of bed and scurried around the hotel room. It was going to take her longer to get ready than it would him, and so Fennel sat on the edge of the bed and waited. Dressed and ready with her makeup on, Mrs. Fennel looked at her husband curiously. She could almost read his mind.

"There's no way out, Curly. You've got to go back and testify."

"I know," he nodded. "Why don't you go down and get us a taxi?" he asked. "While you're at it, check up on that train schedule too."

"Alright. But you'd better get out of that bed and get a move on," his wife said.

He nodded as she opened the door. "I won't be long."

She smiled and closed the door. Halfway down the stairs, the sound of gunfire stopped her in her tracks.

Racing back to the room, she found her husband lying on the bed. There was nothing she, or anyone else, could do for him now. Later, she would tell conflicting stories about Fennel's mood in the days preceding his death. First she would say that he had been fine and had shown no sign of what he intended to do.

Then Mrs. Fennel abruptly changed her story. Her husband, she said, had been acting very strange and kept glancing at his gun in the dresser drawer. The coroner's inquest found that Fennel had died of self-inflicted gunshot wound. But did he? There are many questions concerning the death of Curly Fennel, one of which is what became of that $1,700 cashier's check in his pocket?

Then there is the matter of the $30,000, a lot of money in 1925. Was it enough to make someone kill Fennel? I believe there is more to the story, and it stands to reason that Fennel might stick around until the mystery of his death is cleared up.

THE PORTAL IN THE ENERGY ROOM WITH VIRGINIA

The Energy Room, as Virginia Ridgway calls it, is on the south end of the hotel's second floor. Stand in the room, and you can feel a definite pull. Over the years, countless people have come and tested Virginia's theory out in the mysterious Energy Room. During a recent visit to the hotel, I visited the

Opposite, top: Virginia Ridgway and the author experiment with an Ovilus and dice at the Goldfield Hotel. *Photo by Bill Oberding.*

Opposite, bottom: Virginia Ridgway and the author during a white candle ceremony in the Goldfield Hotel Energy Room. *Photo by Bill Oberding.*

Below: The author during an experiment/investigation of the Goldfield Hotel. *Photo by Bill Oberding.*

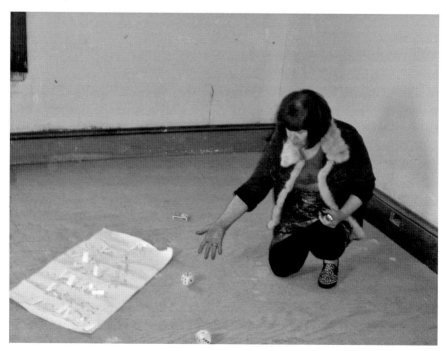

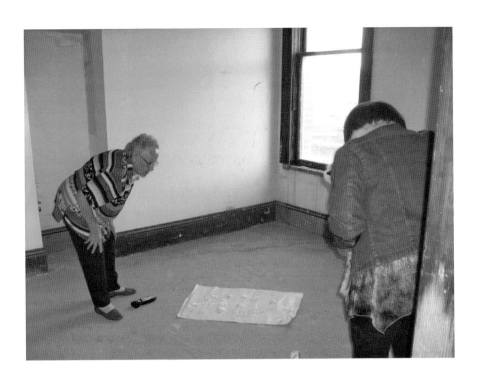

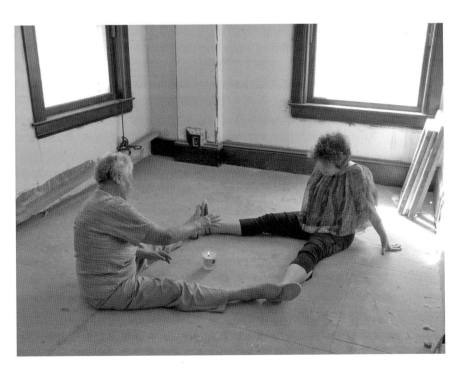

Energy Room with Virginia during the day. With sunlight streaming through the hotel's windows, we stood in the room.

"The energy," Virginia said, "is in this room. Not above or below."

When asked why she thinks the energy is so intense in this particular room, Virginia shrugged. "I have no idea why. It's just there."

And indeed, when I raised my hands to meet Virginia's, I could feel… something.

"When does this generally happen?" I asked, remembering Zak Bagan's *Ghost Adventures* special.

"Anytime day or night," Virginia answered. "For the past thirty years, every foreign psychic comes right to this room and goes to the windows and says, 'This is a pass-through corner to other worlds.'"

"Can this be the source of the portal?" I silently wondered. Some researchers believe that the Goldfield Hotel is one of seven portals to the other world, an open door that permits ghosts to enter and exit the building. Others believe there is nothing ghostly going on inside the Goldfield Hotel at all. What occurs here, they claim, has to do with a time warp, not ghosts.

THE MYSTERIOUS COWBOY GHOST

Virginia Ridgway is sure that the ghost of a cowboy haunts the third floor of the hotel, and she is not alone in this belief. Several people who have investigated the hotel agree with her. They all refer to him as the cowboy. Virginia's first encounter with the cowboy took place years ago.

As she describes it:

> An Esmeralda County sheriff and I were on the third floor of the hotel when we saw the smoke at the end of the hall. I thought some homeless person had crawled in and started a fire. Before I could say, "Let's call the fire department," the smoke suddenly dissipated, and a tall man was standing there, dressed all in black, and as I recall, his hat had a flat crown like the type worn by Wyatt Earp. He leaned against the wall, crossed his legs and just stared at us. His whole body was outlined in an iridescent light, and I wondered who he might have been.
>
> He didn't seem to be as curious about us as we were of him. We asked a lot of questions, things like, "Do you need any help?" "Can you tell us your name?" "Do you know what year it is?"—that sort of thing. I'll

always regret that neither one of us thought about going down there and touching him.

Since then, Virginia has encountered the ghostly cowboy a number of times while leading tours. During one television documentary, the ghostly cowboy made a brief appearance and is seen in shadow just for an instant. Among the many negative spirits and energy here, the ghostly cowboy is one of the good guys. Whoever he was in life, he does not seem to be malicious to those who come to his area of the hallway.

SUICIDE AT THE GOLDFIELD HOTEL

Suicide was a common occurrence during Goldfield's gold rush. Rather than face the harsh realities of life in a mining camp, some chose death as a means of escape. Among women, the favored method for dispatching oneself out of this world and into the next was poison, opium or morphine. Men resorted to either poison or a bullet.

There are at least two deaths recorded at the Goldfield Hotel. Both deaths were ruled suicides, and both took place long after Goldfield's gold rush had passed.

It was barely past midnight on October 1, 1915, when night clerk Irving Truman realized that he hadn't seen J.B. Findly, the night porter, for several hours. Truman wondered what could be keeping the normally conscientious man from his job. As soon as he could get away from his duties at the front desk, Truman went straight to Findly's room in the employee section of the hotel.

When he got no response from his knock on the door, Truman opened it and walked in. There on the floor was J.B. Findly's lifeless body, already cold to the touch. Lying next to the body was a revolver. While everyone remembered Findly acting strangely, no one could understand why he had killed himself. His reasons were his own, and they would go to the grave with him. But that wasn't the last of J.B. Findly.

The death was reported in the *Goldfield Daily Tribune* on Friday evening, October 1, 1915: "HOTEL PORTER IS FOUND DEAD. J.B. Findly is apparent victim of his own hand."

Allen Metscher is a Goldfield historian. The founder of the Central Nevada Museum in Tonopah, Metscher was born and raised in Goldfield;

he has lived here all his life. He doesn't know if the hotel is haunted or not. However, he does remember the story his grandmother told him long ago about her strange encounter with a ghost.

Metscher's paternal grandmother was employed as a maid at the Goldfield Hotel. On the morning after J.B. Findly's death, Mrs. Metscher arrived at the hotel, unaware of the incident. She was greeted warmly by some of her fellow employees at the front door and went about her work. As the day progressed, a co-worker casually remarked that it was too bad about J.B. Findly. Curious, Mrs. Metscher asked what was too bad.

"You haven't heard?"

"No, what?" she asked.

"Findly shot himself in his room this morning," her co-worker replied.

"But he's all right," she said.

"He's dead."

She stared at the man in disbelief. J.B. Findly had been one of the employees who said hello to her as she came to work that very morning. Not given to flights of fancy, Metscher's grandmother told the story of her ghostly encounter with the dead night porter for the rest of her life.

For those who are curious, the employee section of the hotel where J.B. Findly shot himself was located on the first floor in the area of Room 109 and not on the fourth floor, as some believe.

Does the restless ghost of J.B. Findly still roam the halls of the Goldfield Hotel? Perhaps he does. Before Allen Metscher shared his grandmother's story, most ghost investigators were not even aware of J.B. Findly, much less aware of his suicide. It is interesting that Metscher told the story many times but never mentioned the fact that Findly was an African American. I bring this to the reader's attention because of the following incident.

During a ghost investigation of the hotel one evening, a psychic/medium involved in the night's activities came running up to me and said, "There is an African American man who wants to talk to you."

"Did he say who he is?" I asked, convinced that she had encountered the ghostly J.B. Findly.

"No, but he said he has something to tell you," she answered.

I quietly left the group and went to the area of Room 109. "What did he have to tell me?" I wondered. Calling out to Mr. Findly, I turned on my voice recorder and asked what he wanted to say to me. After several minutes of nothing but silence, I decided that whatever it was, it would have to take place another time.

MEMORIES OF THE *GHOST ADVENTURES* GOLDFIELD HOTEL LIVE GHOST HUNT

Just before their TV show gained worldwide fame, the *Ghost Adventures* team did two live ghost hunts. One was conducted at the Goldfield Hotel in Goldfield.

The Goldfield Hotel Live Ghost Hunt was the *Ghost Adventures* team's second event, and in many ways, it was the better of the two. True, it was so cold in the century-old hotel that icicles were literally hanging from some of the basement walls, but c'mon now, we ghost hunters are used to the cold and dark. There was no power in the hotel, and the nearest restrooms were blocks away at the Esmeralda County courthouse or the local bar. Take your pick. If you needed to go, you had a short walk (in the cold) ahead of you. But if you cared to look up at the night sky, you would have seen myriad stars. This place offers some of the best stargazing in the United States.

Food? Anyone who had the munchies after 11:00 p.m. was out of luck; what do you expect in a town that has fewer than three hundred citizens? For the hunt, Zak had also secured the old Nixon office at the John S. Cook Bank building. Can you say creepy? Think of a mannequin with spider web threads glistening out of its nose, old typewriters, a Christmas tree and photos of long dead but very famous Nevadans adorning the walls.

So that no one was walking over someone else, groups were formed and logistics worked out in Tonopah. Once in Goldfield, we all went our separate ways: some to the fourth floor, some to the dreaded basement where Zak and Nick had encountered the flying brick and some to the Nixon. And so the groups rotated throughout the evening. Smooth!

Throughout the night, people gathered EVP and photos. At the group EVP session, everyone chose a room and stood in the doorway with recorders on the floor at the ready. This is where the provocation began. There are those who frown on provoking spirits, and there are those who find it great fun. I admit to falling somewhere in the middle. On this night, Zak was at his taunting and challenging best. "I have gotten braver since the last time I was here," he announced to the Goldfield's ghosts. "You don't scare me."

Remembering how he fled the basement screaming his head off during his hit documentary, I chuckled and hoped this was true. In all honesty, I would not want to spend one minute in that pitch-black basement by myself. For one thing, it's a maze, and given my lousy sense of direction, I may never find my way out again. For another, it's just plain spooky. Call me guilty of scaring myself if you want, but there is something about being underneath an old hotel in the middle of nowhere at 3:00

a.m. that makes you wonder, "What if Hollywood is right, and there are terrible demons lurking here just waiting?" Nah! That's what being tired and hungry will do for you.

All in all, the *Ghost Adventures* team members are very likeable guys, and their Goldfield investigation was great fun, even the strange experience with Virginia, although she might disagree. While I clearly saw the two strange black blobs coming toward us, I never thought they were demonic. Evil, oh yes, but demonic they were not. Virginia insists that this is what happens when you provoke and make the spirits angry. For the longest time, she felt that the ghosts of the Goldfield Hotel were angry with her and blamed her for Zak's provoking of them.

CHAPTER 4
TONOPAH GHOSTS AND STORIES

THE BELMONT MINE DISASTER

A sculpture in front of the Tonopah post office commemorates the worst mining disaster in Tonopah history. Honoring the hero of the Belmont Mine fire, the sculpture was built by Adam Skiles and depicts William F. "Big Bill" Murphy carrying a man to safety.

Sometime between 2:30 and 4:30 a.m. on February 23, 1911, a fire broke out 1,166 feet below the surface of the Belmont Mine. Although the cause of the fire was never officially determined, it was surmised that someone on the night shift had started the fire by carelessly leaving a candle burning.

Fires were deadly in mines; as acrid smoke filled the tunnels, all thoughts aboveground were on how best to get the men to safety and stop the fire. Many miners were able to crawl into the cage and out of the mine. Others were trapped far below the surface, battling for air in the hellish blinding smoke. Big Bill, the day shift cage operator, learned about the fire when he went to work that day. Amid the confusion and fear, Big Bill took the cage down to the 1,100-foot level, loaded up as many men as possible and took them to safety. After repeating his feat for a second time, he was asked if he was up to continuing the task. He reportedly said, "I'm nearly done in, but I'll go again."

Once more he took the cage down, but this time he didn't return. Later it was discovered that Big Bill had perished in the fire, and his body had

A funeral procession for the victims of the Belmont Mine fire disaster. *Photo courtesy of Central Nevada Museum.*

been horribly mangled in attempts to hoist the cage up. The hero had lost his life along with others who were trapped underground. In all, seventeen men perished in the Belmont Mine disaster. The next morning, all the bodies were brought to the surface. Two days later, a funeral was held in a raging snowstorm, and victims of the fire were laid to rest in the (old) Tonopah Cemetery.

THE OLD TONOPAH CEMETERY

Do you love clowns? Then there is a perfect spot for you in Tonopah: the Clown Hotel. It's a favorite of ghost hunters and those who like something a little off the beaten path. However, if you suffer from coulrophobia, fear of clowns, the Clown Motel might not be your best bet when looking for a place to stay the night, and likewise if you're not thrilled with ghosts and hauntings. Fans of the quirky Clown Motel claim it is haunted because of its proximity to the old Tonopah Cemetery, located right next door. Imagine the couple who woke one night to see a group of "greyish misty men" stumbling

around their room. Awake, they realized these were specters, but it made no difference. They hastily packed and hit the road, leaving the haunted Clown Hotel far behind.

Not everyone flees ghosts. Those who seek out such events have made midnight forays into the old cemetery and came away with some interesting EVP for their troubles.

The first residents of the old Tonopah Cemetery were laid to rest in 1901. Tonopah's dead would continue arriving at the cemetery until late 1911, when the new cemetery was ready for occupants. Among the last to be buried here were Big Bill Murphy and several other men who lost their lives in the Belmont Mine disaster. Early residents of the old cemetery included those who died in what was called the "Tonopah Sickness," a strain of pneumonia that occurred in the spring of 1905. The disease affected both Goldfield and Tonopah and was so prevalent that newspaper headlines warned of the sickness, calling it a plague and frightening people from going to either camp for fear of catching it. Many people succumbed to the dreaded disease in 1905, including Virgil Earp, deputy sheriff of Goldfield.

Of those buried in the old Tonopah Cemetery, Nye County sheriff Thomas W. Logan may be the most famous. Sheriff Logan may also be responsible for the amazing EVP of a gunshot that was recorded at the cemetery one spring night by my friend and fellow ghost investigator Jeff Frey. According to Jeff, he came to the cemetery alone and spent about seven minutes trying to collect EVP. Hunger struck, and he decided to scrap the impromptu ghost hunt and head to the local McDonald's. While waiting for his meal, he listened to his recording. To his amazement, he had recorded something that sounded like a car backfiring. He listened again and again. "Wait a minute," he thought. "It was so quiet in the cemetery, and I didn't hear anything like this." After playing his recording for other investigators, he realized he had recorded the sound of gunfire—gunfire from the hereafter. Long-dead Sheriff Tom Logan, the most famous resident at the old cemetery, was most likely testing one of his guns in the afterlife.

Tom Logan served as Nye County sheriff from 1899 until his death on April 6, 1906. In her recent biography of Logan, author Jackie Boor called his death "scandalous"; there is no better word to describe Logan's demise than that.

On the night he died, the well-respected sheriff, a married man with eight children, was with May Biggs, owner of the Jewel, a red-light district saloon in nearby Manhattan. Besotted with Biggs, Logan spent most of his free time at the Jewel.

Logan was killed because a gambler named Walter Barieau shoved May when she asked him to leave. Hearing her scream, the sheriff came running to her assistance, clad only in his nightshirt. He was shot several times in the ensuing altercation. Barieau pleaded not guilty, claiming he shot Logan in self-defense. Barieau was defended by Patrick McCarran.

On July 12, 1906, the *Tonopah Sun* reported how defense attorney Patrick McCarran had informed the jury that Logan's family was neglected after the sheriff met May Biggs. Warming to his subject, McCarran called Biggs "an enchantress who had wound herself into the life of a man inclined to do right and making him a slave to her every will and wish."

After seventeen hours of deliberation, the jury returned a verdict of not guilty. The sensational murder trial had also focused attention on McCarran, who had proven himself a skilled orator and attorney. He would go on to become one of Nevada's most powerful politicians.

Forlorn and nearly forgotten, the Old Tonopah Cemetery is silent—or is it? I was with a group of ghost enthusiasts one night, and we decided to investigate the cemetery. It was just after midnight on a chilly February night, and our plans were not to stay very long. As we wandered among the old tombstones, trying to decipher names and dates, we noticed that many of the residents at the cemetery were very young. Most of them had died of the plague, others from the mining disaster.

"It's too cold even for ghosts," someone remarked. The words were no sooner said than a streak of white light rushed toward us. Only car lights from the highway, I thought—right up until I heard an angry voice hiss, "Get out!"

"Did you hear that?" I asked.

No else had heard it. For me, this was a good sign that it was time to go back to the Clown Motel. I'd had enough ghost hunting for one night.

The Haggard Hitchhiker

Occasionally, a motorist on that lonely stretch of highway near Lida Junction may catch a glimpse of a haggard hitchhiker stumbling along the roadside. A backward glance in the rearview mirror reveals nothing but an empty roadside. A trick of light, a strange mirage, boredom or imagination, no one knows for sure. But there are those who will tell you that the hitchhiker is none other than the late Howard Hughes trekking along a highway he knew quite well in life.

Howard Hughes was connected to Nevada. He owned mining operations near the Comstock, land and mining claims in Central Nevada and several hotel/casino properties in Las Vegas. An often told story involves his purchase of the Desert Inn. Before purchasing, Hughes and his entourage rented the entire two top floors of the Desert Inn and moved in on Thanksgiving in 1966. The problem was, they never wanted to vacate. Management wanted the suites for the high-rollers (those who spent big money freely on the casino floor), but Hughes wouldn't budge. Finally, a deal was struck. Hughes bought the Desert Inn on March 1, 1967.

Then there is the local story of Hughes's visits to the Cottontail Ranch brothel. He was flown in and out by private plane, and no one was the wiser. This, they say, helps explain his being in the vicinity of Lida Junction when Melvin Dummar spotted him. But I've gotten ahead of myself...

When he died on April 5, 1976, at age seventy-one, Howard Hughes left an estate of $2.5 billion dollars. As might be expected, the rush was on to find Hughes's heirs and settle the estate. Service station owner Melvin Dummar stepped forward with the so-called Mormon Will, which he claimed was that of Howard Hughes. If proven to be genuine, this will would have netted him 16 percent of Hughes's estate.

Dummar told a most interesting story while explaining just how he came to be included in billionaire Howard Hughes's will. One night in late December 1967, Dummar stopped in at the Mizpah Hotel. After a quick meal, he spent the next several hours gambling in the casino before climbing into his 1966 Chevy Caprice and heading south on Highway 95. Near Lida Junction and the Cottontail Ranch brothel, he spotted a bedraggled old man lying in the sand along the highway. Thinking the old man was either very sick or dead, Dummar pulled to the side of the road and picked up the man. His passenger wanted to be taken to Las Vegas, some 180 miles south, and Dummar obliged. During the ride, the old man told Dummar that he was Howard Hughes and asked to be dropped off at the Sands. Once more, Dummar obliged. He hadn't believed for a minute that his passenger was billionaire Howard Hughes—until a mysterious man delivered an envelope to Dummar that contained Hughes's will, which could have made him a very wealthy man.

Though the will could have made him wealthy beyond his wildest dreams, Dummar was scorned as an opportunist and a fraud. In 1978, a Las Vegas jury found the will to be a forgery. In his 2005 book *The Investigation: A Former FBI Agent Uncovers the Truth Behind Howard Hughes, Melvin Dummar, and the Most Contested Will in American History*, retired FBI agent Gary Magnesen claims

to have found evidence to support Dummar's story of finding Hughes in the desert. It's a moot point. Dummar never received a dime. Many of the players, like Howard Hughes, madam Beverly Harrell and the Cottontail Ranch, are long gone.

And yet, there is that haggard hitchhiker who wanders aimlessly along the highway near Lida Junction…

TONOPAH'S CURSED AIR BASE

Allen Metscher of Goldfield is the local go-to person for history of the Central Nevada area, particularly that of Goldfield and of Tonopah's old air base. As historians and natives of Central Nevada, Allen and his brothers founded the Central Nevada Museum in Tonopah. Allen is responsible for the museum's Tonopah air base exhibition, which includes a complete history of the Tonopah Army Air Field.

The 1941 attack on Pearl Harbor caught the United States unaware. To ensure that this would never happen again, the military began construction at the Tonopah Army Air Field so that pilots and crews could be trained in the operation of Bell P-39 planes for overseas combat. This would not work out as expected. Within two years, twelve fighter squadrons were trained at the airfield. In that time, fifty-nine fatal accidents occurred involving 257 pilots and crew members. There would be 135 fatalities and 59 aircraft destroyed. Freak accidents were common; the strangest was a machine gun that went out of control, firing in all directions and killing 3 men. A raging fire swept through the barracks, killing 3 officers. An unfortunate B-24 crew member was killed instantly when he walked into a spinning propeller blade. When their oxygen supply was interrupted, 2 men suffocated in gun turrets.

The Tonopah Army Air Field, which some refer to as "Tonopah's cursed air base," is seven miles east of Tonopah. Notables of the day came here to entertain the troops, and Chuck Yeager flew through an open hangar on the base. While the Tonopah airport is located here, the area is desolate; looking at it today, it is hard to believe that there were nearly seven thousand enlisted personnel stationed at this base as World War II wound down. Some of them didn't want to be anywhere near Tonopah. As far as safety was concerned, this was a place with a bad reputation. The accidents and deaths had led to talk that possibly, just possibly, the base was cursed. In truth, there

were many things that could have contributed to the accidents, such as the high altitude, the terrain and inexperience. And yet...

On a recent hot afternoon in late summer, Allen Metscher was leading a tour of the air base. As he talked, participants walked along, gazing into broken windows and skeleton-like hangars. The group stopped in front of a large old building. Suddenly, a woman gasped that she'd seen a young man in uniform inside the empty building. We all peered in. Cameras and recorders were at the ready, but we saw nothing in the old building but dust and cobwebs. Still, she knew what she'd seen, and she insisted she'd seen a young man in uniform, gazing back at her.

Had she let her imagination get the better of her? Or had she seen the ghost of a long-ago serviceman? No one can say for sure, but we do know that many ghost hunters have visited the old air base and proclaimed it haunted.

MIMOSA PITTMAN'S REMARKABLE PHOTOGRAPH

Out across the Nevada desert, a summer thunderstorm can come up quickly. Wind-driven storm clouds are swept across the sky, turning it ominous. Suddenly it is pouring rain, accompanied by the roar of thunder,

Mimosa Pittman's photograph of a lightning strike. *Photo courtesy of Central Nevada Museum.*

followed by the crack of lightning. On August 10, 1904, just such a storm swept into Tonopah.

Mimosa Pittman was fascinated with the new camera her husband, Key, had given her. In the raging storm, Mimosa and Key set the camera up in back of their house. Perhaps they would be lucky enough to capture the mesmerizing phenomena going on around them. At just the right moment, Mimosa clicked the camera and was rewarded with an amazing shot. Sixty-five years later, man would walk on the moon and send photos back to earth. But this was a different time; demand was great for copies of what scientists said was the most remarkable photo ever taken. And being the astute businessman he was, Key Pittman copyrighted the photo.

CHAPTER 5
GOLDFIELD GHOSTS AND STORIES

ESMERALDA COUNTY COURTHOUSE

You wouldn't know it today, but back in 1905, Goldfield was Nevada's largest town, with a population of close to ten thousand. As such, its residents felt their town should be the county seat for Esmeralda County. The citizens of Hawthorne disagreed. They were happy with being the county seat and fought hard to keep it that way, even if theirs was a much smaller town. As the arguments rose up, one person even had the audacity to suggest that Goldfield would not last.

It took nearly two years, but Goldfield didn't give up. The Nevada legislature authorized the county seat to be moved from Hawthorne to Goldfield on May 1, 1907. The only problem was there was no courthouse. That was solved when John Shea of Salt Lake City was awarded the $79,833 contract to build the new courthouse. Shea was no slouch. The courthouse was completed and ready for business in May 1908.

The courthouse is an interesting structure, very different from any of the state's other courthouses. Like some of the other county courthouses in Nevada, the Esmeralda County Courthouse is rumored to be haunted. One of the resident ghosts is that of a longtime judge. His honor has been seen in and around the courtroom many times since his death. A woman told of accidentally bumping into a judge while photographing the court:

The dedication of the Esmerelda Courthouse with county officials on June 18, 1907. *Courthouse 0350 0130, the Boomtown Years Special Collections, University Libraries, University of Nevada–Las Vegas.*

I was just finishing photographing the judge's bench when I stepped back and collided with something. It startled me when I saw that I had bumped into a judge in his black robe.

"I am so sorry."

He looked at me kindly and nodded.

"Your honor, may I—" But I before I could finish asking him if I could take his picture, the judge walked up to bench and was gone. He just…disappeared.

A local took a photo of the judge's bench one night and was surprised to see the face of a former judge staring back at him.

Then there is the haunted chair. If a house can be haunted, why can't a piece of furniture? Is a chair in the Esmeralda County Courthouse actually haunted? That depends on who you listen to. According to some courthouse employees, a chair on the first floor seems to have a ghost attached. The chair will move on its own accord whenever it is removed from its spot at a certain desk. An ordinary straight-back chair made of wood, there is nothing

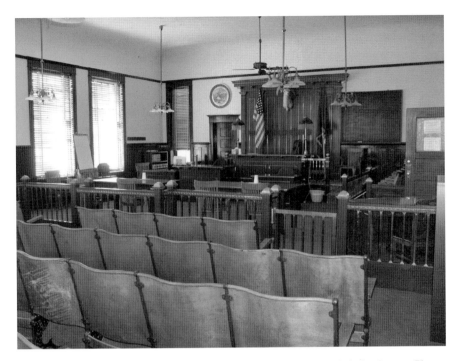

The courtroom of the Esmerelda County Courthouse, where a ghostly judge is seen. *Photo by Bill Oberding.*

ordinary about the stories told about it. The chair has been locked in a vault and somehow managed to return to its rightful spot at the desk in the hallway. Is it the work of ghostly prankster or a living breathing person who enjoys perplexing those who investigate ghostly happenings? Who can say?

If you'd like to photograph or test the chair, be sure not go to the courthouse during busy nine-to-five business hours. Visit in the wee hours of the morning. Things are quiet in the old courthouse at that time and employees are more apt to talk about the ghostly goings-on. Then, too, the chair is less likely to be occupied by a live person.

HAUNTED JAIL

As in many smaller communities, the Esmeralda County jail is housed within the courthouse building. Ghosts are free to come and go throughout the

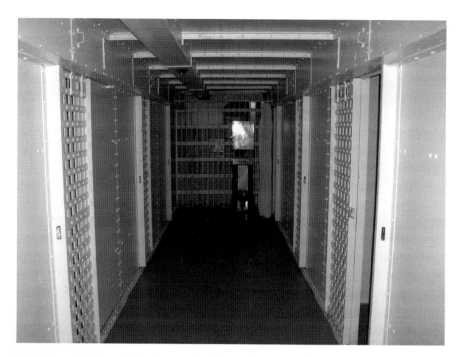

The Esmerelda County jail, where a ghost is sometimes seen. *Photo by Bill Oberding.*

building; inmates are not. Over the years, inmates at the jail have reported hearing strange noises and seeing a shadowy figure walk past the cells. The cell at the end of the row is considered especially haunted.

There have been a few deaths in this hundred-year-old facility located in back of the courthouse. Perhaps some of those who died here have chosen to stay on. After all, some paranormal experts believe jails and prisons are among the most haunted locations there are. But the question is, if a ghost can haunt anyplace on earth, why would it choose to haunt a place where it was most unhappy?

One of the earliest deaths in this jail was the suicide of Edward Hughes in 1908. After having been convicted and sentenced to life imprisonment for the murder of his wife's lover, Hughes escaped punishment by hanging himself in his jail cell. If he is in residence, the ghostly Hughes is serving a longer life sentence then even the judge and jury could have foreseen.

Over the years, a few ghost hunters have even spent the night at the jail—as inmates. The young men were caught trespassing in the Goldfield Hotel, and for their troubles and their crime, they were guests of Esmeralda

Above: The grave of Edward Hughes, the suspected ghost of the Goldfield Jail. *Photo by Bill Oberding.*

Right: The author with an orb in Goldfield Hotel lobby area. *Photo by Bill Oberding.*

County until bail could be arranged. Trespassing is never a good idea, especially at the Goldfield Hotel. You may encounter more ghosts than you bargained for, because you will also go to the haunted jail.

VIRGIL EARP, ESMERALDA COUNTY DEPUTY SHERIFF

The most famous person to live, and die, in Goldfield was probably Virgil Earp. Earp and his wife, Alvira, known as "Allie," came to prospect the area with his brother Wyatt, whose stay in Tonopah lasted but two years. By the time Virgil and Allie Earp settled permanently in Goldfield, Wyatt and Josie had moved on. The Goldfield that Virgil and Allie Earp arrived at on a cold day in January 1905 was very different from the place they had visited a few years earlier. Where there had been only a couple dozen people, there were now thousands. Miners and their families still huddled in tents, crude rock houses and temporary lean-tos, but even in the snow one could see that a flurry of building activity had been taking place. Hotels, saloons, shops and houses were being erected as fast as the necessary lumber could be hauled in. Telephone and telegraph poles dotted the landscape; the rest of the world was now that much closer.

It hadn't been that long since Virgil and his brother Wyatt prospected around Tonopah and not that long since Wyatt ran the Northern Saloon there. Like silver had on the Comstock fifty years earlier, gold had changed everything. Well past his prime, Virgil was old enough to realize nothing ever stayed the same.

He was sixty-two with a crippled left arm, the remnant of a late-night ambush in Tombstone, and now his fast-draw days were well behind him. He might well have died a young man on that long-ago December night in 1881. The doctor had wanted to amputate his mangled arm, but that was something Virgil could not allow. Instead, four inches of bone was sawed away from his elbow.

Old and tired, Virgil came to Goldfield hoping to open a saloon like Wyatt had done in Tonopah. Instead, he took a job as a deputy sheriff for Esmeralda County. He had been a lawman most of his life and knew the job. If his health had held out, he might never have come here to Goldfield. He might have ended his days as the sheriff of Yavapai County in Arizona. In 1900, when he accepted the Republican party's nomination to run for sheriff, he said, "I was nominated, and if elected you can count on it that I will, as in former years, stand for good government and the protection of property."

But it wasn't to be. Virgil was slower and frailer than in his younger Tombstone days. Time had finally caught up with him. With his health deteriorating, he had no choice but to withdraw from the race.

Five years later, he was in Goldfield, pinning on a badge. This town had its share of killings and robberies, but nothing like Tombstone in the old days. There were no rowdy shootouts in the streets; the job was relatively easy for him. And so he went about the task of being a deputy sheriff, an old man keeping the peace.

That spring, Wyatt and his wife came to Goldfield for a short visit. On February 11, 1905, the *Tonopah Sun* announced his arrival:

> *Verge Earp, a brother of Wyatt and one of the famous family of gunologists is acting as a deputy sheriff in the National Club, Goldfield. Verge is a mild looking individual and to the outward view presents none of the characteristics that have made the family a familiar one in the west…*
>
> *Wyatt is expected in Goldfield shortly. He is coming overland from Los Angeles with his wife, dog and trusty rifle…In a recent letter to his brother…Wyatt asserted that he would "Never shoot at a man unless he tried to shoot at me first."*

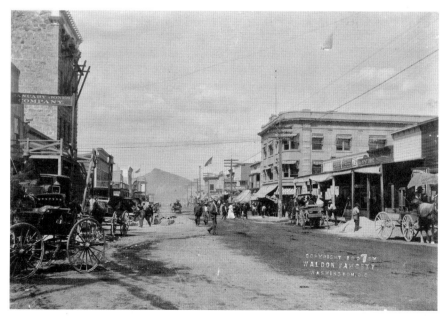

Early Goldfield, circa 1907. *Library of Congress.*

Even as the brothers reminisced about the old days, of Morgan and the others they had known and loved who were dead and in their graves, time was running out. Virgil contracted pneumonia that fall, about the same time that electricity was brought to Goldfield. The town was lit up like never before.

A week later, the train rolled into Goldfield for the first time. It was September 15, 1905, and the future had arrived. Goldfield was jubilant. Three days of celebration followed. Although he was witness to it, Virgil was too old and too sick to celebrate the progress that was happening all around him. Try as he might, he could not shake the cough, the chills and fever. Every breath was tortuous. Soon he was bedridden. His wife, Allie, knew the truth; he would never get any better.

She took him to the county hospital, where he was given a bed and made as comfortable as possible.

"Light me a cigar, Allie," Virgil said.

She handed Virgil the cigar and watched him try to puff on it without coughing. "Sit here awhile, Allie, and hold my hand."

Virgil died of pneumonia on October 19, 1905. The October 20 issue of the *Goldfield News* carried the following obituary.

Makes Final Camp
Virgil Earp Has Followed the Trail Across the Great Divide

A noted frontier character crossed the Great Divide yesterday in the person of Virgil Earp. In the early days of Tombstone, Ariz. from 1879 to 1882 when the camp vied with Leadville in being the toughest camp on earth, the Earp boys, consisting of Wyatt, Morgan, Virgil, Warren, James and one other the writer cannot now recall, were among the best men in America. All of them would fight at the drop of a hat—and two of their number, Morgan and Warren[,] were killed in personal altercations. Wyatt, who was afterward marshal of Tombstone and one of the pioneers of Nome, Alaska[,] is residing now in Searchlight, and James lives in Sawtelle near the Old Soldiers' Home in Los Angeles County California. The father of "the boys" as they have always been called, a veteran of the Civil War, lives at the soldiers' home and is enjoying a ripe old ages [sic]. During one of the scrimmages of the Earp boys in the Tombstone days[,] the Lowery brothers and Billy Clanton were killed. For more than a year past[,] the deceased Virgil Earp, a quiet unassuming man, has been engaged as a special officer at the National Club in Goldfield.

He endeared himself to all who knew and left behind a host of friends, and Charles B. Stocking, an oldtimer [sic] in Arizona who knew him well gives him a very high character. The deceased was ill only a short time with pneumonia and died at the age of sixty-two years, after having led a more exciting life than comes to the average man.

The *Nevada State Journal* carried a different obituary in its October 25, 1905 issue:

Virgil Earp, Gunfighter, Cashes In

Considering the general reputation of new mining camps, it speaks well of Goldfield that Mr. Earp was permitted to go hence with his boots off…

By all means, you should visit the Goldfield Cemetery next time you're in town. But don't waste your time looking for Virgil Earp's grave site. He's not there. His only daughter had his body sent to Oregon, where she lived. Virgil Earp is buried at the Riverview Cemetery in Portland, Oregon.

While there have been no reported (or admitted) sightings of the ghostly Virgil Earp, there is the sound of boots shuffling along near the site of the old Northern Saloon. And there's the eerie incessant cough that drifts in on certain nights at the site of the old hospital where Virgil Earp breathed his last. Another theory I would like to put forward is this: on the night that I investigated the Goldfield Hotel with Helmey Kramer, Jen Peterson, Richard St. Clair and Cimarron Sam, many strange things happened. The sound of boots walking toward us and suddenly stopping as if face to face with us was among the weirdest. Although the hotel wasn't built until three years after Virgil Earp died, who is to say this wasn't Deputy Earp checking up on what was going on in the hotel?

THE JOHN S. COOK BANK BUILDING

The John S. Cook Bank building was constructed in 1907 by Loren B. Curtis and Marvin E. Ish. For the next twenty years, the bank would be Goldfield's financial hub. When the $30,000 purse was finally agreed upon between boxer Joe Gans's management and that of his opponent Nelson, all the money was displayed here in a neat stack of gold coins. Money,

A mannequin in the John S. Cook Bank building during a night investigation. *Photo by Bill Oberding.*

money, money—even if there are no ghosts in the building, think of the cash that's spent some time here.

Several years ago, I was involved in a ghost investigation in which I was given the opportunity to investigate the John S. Cook Bank building with a group of ghost investigators. It was well past midnight as we eagerly made our way from the Goldfield Hotel to the bank building, a few blocks away. But on this midwinter night, it seemed like miles. Thousands of stars were shimmering overhead, and the temperature was barely above freezing. Columbia Street was a sheet of ice.

It was dark inside the bank building. In the shadows, the antique items took on an eerie appearance. On the walls were photos of George Wingfield and other long dead but very famous Nevadans. We broke into two smaller teams. While one group went into the small room to do an EVP session, the other stayed behind in the main room, quietly filming.

During ghost investigations, there is always a sense that we, the living, are the intruders. This night was no different. This building seemed to be of the past, and it felt like we didn't belong here. Suddenly, someone in the group brushed past me in the darkness and angrily stomped upstairs.

When the investigation concluded, I asked, "Everyone ready to go?"

"No!" someone shouted from upstairs.

"It's time to go," I replied. From upstairs came only silence.

Someone in the group ran upstairs to hurry the straggler along. A moment later, he came downstairs and announced, "There's no one up there."

Then who ran past me and stomped up those stairs? Who answered me when I asked if we were ready? There was no time to answer those questions.

On a subsequent investigation in the building, a participant was forcefully pushed on the stairs. According to Goldfield lore, the infamous Barbara Graham had an office in an upstairs room of the building back in the late 1940s or early '50s. In 1955, thirty-two-year-old Graham was executed at San Quentin for the 1953 murder of an elderly woman in Glendale.

Dubbed Bloody Babs by the news media, Graham worked as a waitress and a nurse's aide in Tonopah during the late 1940s or early '50s. But did she have a Goldfield connection? What was it? And why would she have an office? She was not a secretary, professional or mine owner. However, the attractive woman had served time for prostitution in California. It was how she typically made her living. Perhaps the phrase "had an office" has been passed down as some sort of euphemism for prostitution.

Whoever pushed the woman on the stairs of the John S. Cook Bank building was not the kindest of spirits. We may never know if it was the ghostly Barbara Graham or another spirit.

There is some wonderful news for ghost hunters concerning the John S. Cook Bank building. The building has recently been acquired by Elite Vegas Paranormal Society Inc. The plans are to permit group tours, ghost investigations and research. The building will be brought to a state of arrested decay. And this brings me to my next point.

I recently read an article with a stated premise that ghosts are bad for old buildings. In other words, once ghost hunters get wind of a place being haunted, they storm in and destroy it. This could not be further from the truth. As an example, I refer you back to the Elite Vegas Paranormal Society's acquisition of the John S. Cook Bank building, and the group's plans for the historic old building. Most ghost hunters are historians (to one degree or another), and they are also preservationists (to one degree or another.) They cherish the past, for this is from where ghosts emerge. It is partly because of (and not in spite of) ghost hunting and ghost hunters that interest is being renewed in old buildings across the nation. This helps to bring much-needed funds for restoration and preservation.

THE GOLDFIELD CEMETERY

The Goldfield Cemetery is a short distance from town, just across Highway 95. It is one of the few cemeteries in the country that offers free plots to the local population. That's right. Goldfield's residents are assured a rent-free

Left: Goldfield Cemetery
Sign. *Photo by Bill Oberding*.

Below: Goldfield Cemetery.
Photo by Anne Leong.

piece of desert in which to spend eternity. However, the town does not pick up the entire tab. The occupant's estate must pay the cost of digging the grave.

The cemetery was moved when the railroad came to town in 1906. Goldfield's movers and shakers didn't want someone stepping off the train to be put off by the proximity of the depot to the town's cemetery, and so those resting in peace were dug up and relocated to new graves at the present location. The men who did the task were dubbed "ghouls." Not wishing to give offense to the living, these men worked by night while most of Goldfield slept. There was enough going on in town without residents having to witness such gruesome work.

Goldfield Cemetery is not a fancy cemetery. There aren't many elegant marble headstones, carved angels or towering obelisks honoring the dead who rest here. Simple wooden crosses and markers suffice and dot the cemetery. Unlike some earlier boom camp cemeteries, the Goldfield Cemetery is an equal opportunity cemetery. Sinners and saints lie side by side.

Some of the people who came to Goldfield only meant to stay awhile, but fate stepped in and here they remain. If not for one man's efforts, many of them would be long forgotten. Bryan Smalley is a man with a mission. The retired Esmeralda County deputy sheriff owns and operates Hidden Treasures Shop in Goldfield. In addition to dispensing tales of local history to tourists who wander into his eclectic shop of used goodies, Bryan keeps busy with his woodcarving, building and headstones. Smalley has taken it upon himself to ensure that those who lie forgotten in unmarked graves at the Goldfield Cemetery have some remembrance of their time here on earth, whether a wooden cross or a wooden headstone. Armed with what information he can glean from old records, he goes to work.

The unknown man was one of the first residents of Goldfield Cemetery to have received a headstone from Bryan Smalley. No one ever knew who he was or why he came to Goldfield. In the days before fingerprinting, driver's licenses, social security cards, credit cards and other means of identification, it was easy to remain anonymous, and if you died alone without friends or family, anonymity was assured. How the unknown man met his death, however, is no mystery.

On a hot July afternoon in 1908, an elderly man ate library paste and died as a result. Was he so hungry that he hoped to fill an empty belly? Did he realize that the paste was deadly? If so, why did he want to die? Was he suffering from some ailment that drove him to consume the poisonous paste? We will never know the answers to these questions.

And so he is spending eternity under the shadow of Malapai Mesa, his identity unknown and his secrets safe.

MARTIN ROWHER

Summers in Central Nevada can be hellishly hot. So it was on July 17, 1908, a day that found Martin Rowher (also sometimes spelled "Rohwer") hungry and trying to find a way out of Nevada. Times were tough. Without two nickels to rub together, he didn't see a way out of his poverty. It hardly seemed fair for him to be so down on his luck, with all the money changing hands in this town. He didn't want all of it, just enough to buy himself a decent meal and a fast way out of Nevada. There was nothing here for the Spanish-American War veteran. He had lived in Nevada long enough to realize this wasn't where he wanted to be. But for now his stomach growled, reminding him of just how long ago his last meal had been. He was hungry, and a hungry man will do a lot of things he wouldn't ordinarily do.

Unlike Martin Rowher, high graders, who were robbing the mine owners, weren't going without. They knew how to profit at the mine owners' expense, a fact that infuriated the owners who were being cheated out of gold that was rightfully theirs. The losses were staggering. Special security officers were hired to keep watch on the mines and quell some of the thefts. It was one of these officers that Martin Rohwer met that night in July as he crawled out of a mine shaft with nearly twenty-five pounds of gold ore.

Rohwer didn't try to explain. He was shot twice as he tried to flee. In a dying statement, he explained his reasons for resorting to thievery and absolved the officer of any wrongdoing in his shooting. "It was all my fault," Rohwer admitted. "I had to have the money."

Now he would never leave Nevada. An old Goldfield tale has it that Rohwer is one of the ghosts who roam the cemetery when the rest of the world is sleeping.

LITTLE JOY FLEMING

Her headstone reads simply JOY, and this is her story.

Joy's family came to Goldfield in 1906 with big dreams and little money. Someday they would live in a fine house, wear nothing but the most elegant of clothing and always have plenty of food on the table. These are the things Herbert and Anne Ellis promised themselves, their son and Anne's two daughters.

Like thousands of others, they dreamed of striking it rich in nearby gold mines and of living happily ever after. Sadly, their dreams were not to be

Little Joy's grave at the Goldfield Cemetery. *Photo by Bill Oberding.*

realized in Goldfield. Within a year of their arrival, both the Ellis daughters fell ill. Ten-year-old Joy was the worst off.

The doctor found the little girl suffering from diphtheria. Living conditions in camp were unsanitary squalor, and diseases were rampant. "All we can do is wait and see," the doctor told the worried mother.

And so, hoping for a miracle, they waited. But Joy only got worse. She died one summer afternoon as the sun bore down on the Malapai Mesa. Early the next morning, she was buried. Afterward, her parents went back to their cabin, the thought of their eldest daughter lying in a cold and unmarked grave weighing heavily on their hearts. But headstones were costly. They barely had enough money to put food on the table. A headstone was an impossibility.

That night, Joy's mother cried herself to sleep. Tossing and turning, she suddenly woke with an idea. One of the large white stones being used for the stairs of the new Sundog School would make a headstone. She could chisel Joy's name on it.

Most of Goldfield was still asleep. If she were going to put her plan into action, she would have to act fast. She waited until after midnight before

crawling out of bed. Her husband was sleeping soundly; there was no need to disturb him. She silently crept out of the cabin, and pulling an old toy wagon behind her, she headed for the Sundog School. The streets were still dark and silent. No one would see her as she loaded the heavy stone block into the wagon and started for the cemetery. Once there, she placed the block on Joy's grave and spent the rest of the night chiseling the simple message "Joy" onto the stone.

When morning came, little Joy was no longer resting in an unmarked grave. The family didn't stay in Goldfield where they had found only heartache. Within the month, they moved on to Bonanza, Colorado.

Later in her life, Joy's mother, Anne Ellis, was awarded an honorary degree from the University of Colorado in 1938 after writing three remarkable books. In *The Life of an Ordinary Woman*, she tells about mining camp life, the family's struggles in Goldfield and the death of her daughter Joy. *Plain Anne Ellis* picks up where the first book leaves off. In *Sunshine Preferred*, published four years before her death, Ellis, older, alone and facing severe asthma, wrote of her life, her activism for women's rights and of her three terms as the elected treasurer of Saguache County, Colorado. She died in Denver at age sixty-three in 1938.

No doubt, Ellis's books are the reason Joy's grave has been visited by people from all over the world. Many still stop and place flowers on the little girl's grave. In the early 1960s, a tourist happened to stop in the cemetery at dusk. No one else was about, so he waved his flashlight across the sagebrush-strewn grounds, focusing on Joy's grave. Suddenly, a child went scampering off, as if she had been frightened by the light. He may have encountered the ghost of little Joy Fleming. She's certainly been seen in the cemetery over the years.

Those who've investigated in this cemetery claim Joy is not the only ghost who wanders here. The other ghost, however, is not so easily frightened. A new team who ventured in one full-moon night came away swearing never to return.

"You don't belong here. Get out!" a disembodied voice growled at them. Anxious to get some EVP, they turned their recorders on and asked the ghost to tell them his or her name. Not one word or sound was recorded. The team got nothing for their troubles except for flat tires on every one of their vehicles. Was it coincidence, a prank-playing local who didn't want anyone in the cemetery or...

By the 1980s, little Joy's headstone had stood there in the desert cemetery for over seventy years. State employees replaced it with a new stone, and this probably makes little Joy very happy.

THE MURDER OF COUNT CONSTANTIN PODHORSKI

Occasionally Bryan Smalley meets a grateful distant relative of someone he has memorialized with a simple headstone or cross in the Goldfield Cemetery. Such is the case of Count (Konstanty Maciej) Constantin Podhorski.

Count Podhorski was born in Mikolajowka in the tsarist province of Kiev in 1859. The son of a Russian princess and a Polish count, he held the title kniaz (which roughly translates to duke or prince.) After serving in the Russian Imperial Army, Podhorski, who was fluent in six languages, traveled the world. Among his friends were the famous, the wealthy and the politically influential.

In 1896, gold was discovered in the Yukon. When news reached the United States, thousands of men headed north to Alaska in what would later be known as the Klondike Stampede. Five years later, Count Podhorski was living in Nome when a friend introduced him to John Rosene, owner of the largest shipping and fishing business in the Pacific Northwest.

A shrewd businessman, Rosene realized that an excellent business opportunity existed on the Siberian coast if he could persuade the Russians to agree to a trade agreement. Podhorski set to work writing friends and acquaintances in St. Petersburg, Russia, on Rosene's behest. Within a few months, he received a telegram asking him to bring Rosene to St. Petersburg to further discuss his proposition.

The two men set off for St. Petersburg from Seattle and arrived in the middle of December 1901. Podhorski was called on to use all his powers of persuasion against a strong anti-American sentiment.

"The spirits there were against Americans," he would later write.

The Russians did not like American gold seekers crossing the Bering Strait to the Chucki Peninsula in their quest for gold. But they could hardly deny the weight of Podhorski's argument. Rosene was awarded his concession on the Chucki Peninsula.

During a social event, Podhorski was introduced to Jack Hines, known as the Merry Minstrel of Nome. With Hines was his wife, Edith. The count kissed her hand in the European fashion and lifted his eyes to meet those of the much younger woman. He was entranced. It mattered little that the pretty woman was married to another man. He meant to have her one way or the other. With his good looks, the suave, sophisticated count easily captured the hearts of women wherever he went. Edith was no exception. She would easily be just one more conquest.

After that first meeting, the count made it a point to invite Jack and Edith to his elegant dinner parties. Innocent and impressionable, Edith fell for

the smooth-talking Podhorski. Soon they were involved in a clandestine romance. It didn't take much persuading for him to convince her to run away with him. The lovers boarded a boat for Canada, leaving her husband, Jack Hines, behind in Alaska. Hines's heartbreak turned to fury. He would have his revenge, just as Harry Thaw had his.

The country was fascinated with the murder that had recently taken place in June 1906 on the rooftop garden of Madison Square Garden in New York. Irate millionaire husband Harry K. Thaw had shot and killed the famous architect Stanford White in full view of hundreds of playgoers. The reason for the murder was simple: Stanford White had debauched Thaw's beautiful wife, Evelyn Nesbitt, years earlier. Hines saw the similarities between Edith and Evelyn Nesbitt and between his outrage and that of Thaw. Determined to kill the count, he followed him from Alaska to New York to San Francisco and to Nevada.

When the private detective he had hired told Hines that Podhorski was in Goldfield, Hines came to see for himself. He spent two weeks watching them and waiting. On March 21, 1907, he finally got his chance to even the score.

Stars blazed across the night sky, and a crescent moon hung high over Malapai Mesa. It was nearly midnight, and in the Tenderloin, Victor Ajax's Sunset Café was alive with raucous laughter and the tinkle of glasses. Incandescent lights cast a soft glow across the faces of those who ate and drank happily. Seated at a table near the door were Count Podhorski and Edith. Unaware of danger, Podhorski sipped a glass of wine while awaiting his meal.

Jack Hines walked into the crowded restaurant and spotted the two lovers immediately. All the anger he held toward this man rose up inside him. Without a word of warning, he pulled his revolver and fired twice. The bullets hit their mark. Count Podhorski slid from his chair dead. Not satisfied, Hines fired two more shots at him.

The Sunset was a frenzy of screaming as frightened patrons ducked for cover beneath their tables. Realizing they were afraid he was a madman who might also shoot them, Hines dropped his gun and held his hands up for silence.

"Ladies and gentlemen, I want to say that this man betrayed that woman. She was my wife. He ruined my life. And I have come seven thousand miles to kill him. Now I am prepared to pay the penalty for slaying the dog." With those words, Hines walked to the bar and waited for the deputy to come and arrest him.

Edith dropped to her knees, softly sobbing as she wiped blood from the count's face. "Please, oh please, speak to me," she begged. Someone pulled her away from the dead man, and a tablecloth was thrown over him.

On hearing of Count Podhorski's death, Florence Ziegfeld, creator of the famous Ziegfeld Follies, said that he and the count had been on friendly terms for several years after having met in Beirut. He was astonished that his friend had been murdered in such a way. He said, "The count was a dead shot and always went well armed. Certainly he must have been caught off guard or else he was shot from ambush. I never met the count in this country but from mutual friends I have heard that he met with financial reverses and that nearly all his fortune had disappeared. He was tall and handsome and a great favorite with the ladies."

The "great favorite with the ladies" was taken to the morgue just about the time his killer was being escorted to jail. Edith disappeared into the night, and the question on every person's mind was whether or not a man should pay the ultimate penalty for killing his wife's seducer. The Harry Thaw murder trial was still fresh in their minds. Stanford had seduced Mrs. Thaw, albeit long before she ever met Harry Thaw, but a debaucher was a debaucher. Thaw was found not guilty by reason of insanity. Surely Hines's shooting of the count was justified under the unwritten law.

Count Constantin Podhorski was unceremoniously laid to rest in the Goldfield Cemetery; none of his family or famous friends was in attendance, and it was a sad and lonely burial for a man of royal ancestry, a man who had traveled the world.

At his murder trial, Hines proved that he could please a crowd. While testifying, he broke into a medley of love songs, impressing everyone in the courtroom with his fine tenor voice. This, coupled with Edith's tearful expression of shame on the witness stand, helped to sway the jurors in his favor. He was acquitted of the murder charge and allowed to walk out of court a free man.

Forty years later, Jack Hines touched on the killing in his book *Minstrel of the Yukon*. Apparently memory had not served him well. The circumstances surrounding the killing were greatly sanitized, and Edith's name was changed to Mary. Strangest of all was his assertion that Nevada governor Sparks had visited him while he awaited trial and assured him that everyone was on his side.

Within a few years of the publication of his book, Hines and Edith were divorced. He continued his writing and singing career until the end of his life in 1962.

Count Podhorski's grave. *Photo by Sharon Leong.*

Not so long ago, a relative of Count Constantin Podhorski contacted Bryan Smalley for information. He traveled to Goldfield from across the world. He stopped in the Sacred Heart section of the Goldfield Cemetery and paid his respects to the long-dead ancestor who lies buried here in the desert, thousands of miles from his homeland.

But it's all good. You see, there are those who believe that Constantin Podhorski is one of the many ghosts who seem to be enjoying an afterlife party in the old red-light district of Goldfield night after night. During an EVP session one night in this area, the question was asked, "Can you tell us about your home?"

The reply came swiftly: "It is a long way…"

MADAM BEVERLY HARRELL: THE MADAM WHO ISN'T THERE

Beverly Harrell, madam of the world-famous Cottontail Ranch brothel at Lida Junction on Highway 95, would probably have appreciated the irony

when the IRS took over the infamous Joe Conforte's Mustang Ranch. He owed $16 million in back taxes and had no way to pay it. The Federal Bureau of Land Management would become the owner of the brothel. Years earlier, Harrell had faced the bureau in federal court over the way she was putting leased federal land to use. She lost the case, but the Cottontail was just a circle of mobile homes, and moving just down the highway hadn't been all that difficult.

Times change. Harrell was two years dead when the Mustang Ranch empire came crashing down. But her Cottontail Ranch was still going strong under her husband's direction. People in Goldfield remember well that day in 1974 when Beverly Harrell announced her candidacy for the Assembly seat in the state's Thirty-sixth District. She wouldn't be the last person involved in the brothel business to run for public office in Nevada.

As she jumped up on the bar at the Santa Fe Saloon, Harrell proudly announced, "I'm tossing my hat in the ring!"

"I'll show them how to run an orderly house" was her slogan. Many voters believed her. The race was as close as it gets. Her opponent beat her by a mere 122 votes. Undeterred, she wrote *An Orderly House* about her life as a madam of the Cottontail Ranch.

The ranch made headlines when Melvin Dummar filed the so-called Mormon Will, claiming it to be that of Howard Hughes. According to Dummar, he stopped for the hitchhiking billionaire one night on Highway 95 near the Lida Junction.

It was later surmised that Hughes had been visiting a girl at the Cottontail Ranch and was on his way back to Las Vegas when Dummar picked him up. Surely Beverly Harrell knew whether or not Hughes visited the Cottontail Ranch. She chose not to speak publicly on the subject.

Her headstone in the Goldfield Cemetery is inscribed simply "A Fearless Beauty of Class and Intellect." This is a place for those who knew and loved her to come and pay their respects. But Beverly Harrell is not buried here. She rests a thousand miles away. According to a friend of hers, Harrell is buried in Florida near her family.

GOLDFIELD'S LOST TREASURE

Somewhere in a mine dump between Goldfield and Diamondfield, or so the story goes, two men buried twenty sacks of high-grade gold ore worth

$1,000 each. That was in 1910. Imagine what the ore would be worth on today's market.

Goldfield old-timers believe the buried treasure is still out there in the desert somewhere. Will it ever be found? It's hard to say. Rather than draw themselves a map, the men consigned the exact location of their buried treasure to memory. If only they had lived long lives, but they didn't. Nor had they counted on the vagaries of fate. Both men died before they could go back and retrieve the sacks and their valuable content.

Over one hundred years ago, a flashflood in the middle of the Central Nevada desert came without warning. There was no escape for the two women who lost their lives in the watery onslaught that rushed into their houses and swept them away. Everything in the flood's path was washed away and lost. According to Goldfield lore, two safes filled with gold coins were among the missing items. To this day, the safes and the loot have never been located. This isn't for lack of trying. Everyone who ever foraged in the debris and mud came away empty-handed. If some treasure hunter was lucky enough to find the mud-encrusted safes, he or she has remained tight-lipped about the discovery.

The *Goldfield Daily Tribune* of September 14, 1913, described the flood:

> *The cloudburst rushed down on Goldfield yesterday afternoon at 2:15 o'clock from two sides. It had been raining heavily since an hour before noon, and for half an hour lightning had been flashing over the camp and the thunder had been deafening. Suddenly the rain changed to hail, there was a distant roar as a great black cloud that had covered all the sky to the south seemed to drop to the hills, and then the water came. Down Rabbit Springs Canyon a foaming wall many feet high tore its way, wiping out all traces of the road up the canyon, and this came down to South Main Street almost unbroken; sweeping before it the cabins that were scattered along the street and then tearing through the red light district along Main to Myers, down Myers to the center of the gulch, while another and larger body of water clung to the channel of the arroyo.*

Fire was just as deadly as a natural disaster in early day Goldfield. During the early morning hours of July 6, 1923, a fire broke out across the street from the Goldfield Hotel. This was the height of Prohibition, and some enterprising person had been operating an illegal still in the shack next door to Brown Parkers Garage. The fire started when the still exploded.

Within minutes, the flames consumed the shack and the garage. The heat was so intense that windows in the Goldfield Hotel were destroyed. Swept up in a northeasterly wind, the flames leapt from building to building.

David McArthur stared in disbelief as the windswept flames destroyed one edifice after another and converged on his little shoe shop on the corner of Main Street and Miners Avenue. His belongings would soon be ashes, and there was nothing he could do. He sank to his knees, as pain ripped across his chest. Stricken by a fatal heart attack, McArthur breathed his last as his shop and the adjacent Downers Brothers Assay Office crumbled in the flames.

The luckless McArthur was the devastating fire's only fatality. All his possessions were a pile of rubble—or were they? Rumors had circulated for years about the miserly McArthur. Perhaps there was some truth to the story that a cache of gold coins lay buried beneath his shop.

Years passed, and most people forgot about old David McArthur, his unfortunate death and his gold coins. But some remembered. In 1936, Robert Niccovich set to work at the site with his doodlebug (dowsing rod.) Niccovich spent long hours sifting through the ruins, but he was convinced that he would eventually be rewarded.

As he worked, others may have thought him crazy to be pursuing such a tall tale. But when his shovel hit something metal, he knew he had been right. Niccovich quickened his pace. An hour later, he withdrew a box, pried it open and stared at an old cast-iron Dutch oven. Eureka! The oven contained 1,321 twenty-dollar gold pieces.

SANTA FE SALOON AND MOTEL: GOLDFIELD'S OTHER HAUNTED INN

Located on the northeast side of Goldfield, the Santa Fe Saloon was built in 1905 by Hubert Maxgut and is one of Goldfield's oldest continuously operating businesses. Ghost investigators agree that there is at least one ghost on the premises. This, they say, could be Hubert Maxgut himself. On August 27, 1912, Maxgut and F.M. Brown got into a fistfight in front of the Santa Fe. Maxgut had accused a friend of Brown's of inappropriate behavior toward a local little girl. Maxgut got the better of Brown with three good punches until Mrs. Maxgut stepped between the men and broke up the fight. Brown went into the Santa Fe to wash the blood from his face.

Maxgut followed him. Standing in the doorway with daylight behind him, he raised his hand to fire his pistol, but Brown ducked just in time. As Maxgut took aim for a second shot, Brown pulled his own gun and fired at his aggressor. The bullet pierced both of Maxgut's lungs. The shooting was

The Santa Fe Saloon. *Photo by Anne Leong.*

The Santa Fe Saloon during an investigation. *Photo by Anne Leong.*

found to be a case of self-defense; Brown was found not guilty, and Hubert Maxgut was buried in the Goldfield Cemetery. But he doesn't rest there, according to some.

Today, the saloon has cold beer and slot machines and is a respite for those just passing through. For the road-weary, the Santa Fe Motel offers eight units. It's the only lodging in Goldfield, and like the saloon, it is haunted. The ghost is an old miner who silently slinks through rooms, oblivious to his surroundings.

Years ago, I stayed at the Santa Fe and was warned about the ghost. My thoughts were on those at the Goldfield Hotel, however, and I couldn't have cared less if the old miner made an appearance or not. He didn't. But neither did I sleep very well that night. I tossed and turned away the hours, dreaming of an old man who came into my room in search of something he'd lost. The more I told the old guy that I didn't have a clue about what he was looking for or where it might be found, the more agitated he became. The next time I stayed at the Santa Fe, I made it a point just before bedtime to say aloud that I wanted no bad dreams or visits from ghosts. No point in taking chances.

Virginia Ridgway with the author in front of the historic and haunted Santa Fe Saloon. *Photo by Bill Oberding.*

It does seem that skeptics and those who don't believe in ghosts seem to have some of the *best* ghostly encounters. This goes double for those who take pleasure in poking fun at ghost hunters. So it was that a friend and I were in Goldfield for an all-night investigation of the Goldfield Hotel. She had brought along her new boyfriend, a nice guy who regaled us at dinner with how silly he thought we were for looking for ghosts in the decrepit old building. "Especially," he laughed, "when everyone knows there's no such thing as ghosts."

We were used to people who thought that way, so we laughed it off. The plan was that he would stay the night in their room at the Santa Fe while she and I hunted ghosts.

Several hours into the investigation, we went back to their room for coffee and snacks. Instead of teasing us about the ghosts we'd encountered, he was sullen. "Did you say this room is haunted?" he asked my friend.

"I said the motel is haunted, and there's a good chance the ghost might wander in," she replied.

"He did."

We stared at him, waiting for the punch line.

"I saw him! An old man looked like he was dressed to go out into the mines. Walked right through the wall over there," he pointed to the wall. "Then just big as you please, he walked right on through."

"Oh, okay," We laughed, but his silence told us he was in earnest.

"I want to go back to Vegas," he said.

"But we've not finished our investigation."

"I don't like this room, and I want to go home," he said.

This ended our investigation of the Goldfield Hotel that night. And those who believe in ghostly goings-on had a new—if not happy—convert.

Later, I asked Virginia Ridgway if she had any idea who the ghost might be. She did.

Since Goldfield's famous blind miner Heinie Miller had lived in a nearby cabin, Virginia thought the ghost who wandered through the Santa Fe might just be him. After all, Miller often stopped at the Santa Fe to visit with his friend Jim Fuetsch, who owned the place.

Heinie Miller had gone about his routine job for so many years that he could have done it in his sleep. One morning in 1927, Miller's life was changed forever when he accidentally struck a dynamite cap. Blinded by the blast, he lost his job and couldn't find another. No mining operation in Goldfield wanted to hire a sightless man. Mining was all he knew. If no one would give him a job, the determined Miller decided to work for himself.

Ghost hunting in Goldfield with an infrared camera. *Photo by Sharon Leong.*

He had his own claim some three miles from town, and he was certain it was worth working. The only problem would be in getting there every morning. Heinie's friends were determined not to let his blindness keep him from his life's work. One night in the Santa Fe Saloon, they got together and talked it over. After much debate, the men devised an ingenious plan. They strung a three-mile length of wire from Heinie's cabin to his claim. By grasping hold of the wire, he was able to find his way to and from his mine each day, and Heinie continued doing what he knew and loved: mining.

Word quickly spread about Goldfield's blind miner. Here was the perfect human-interest story. The news media wanted to know more about Heinie, and he was glad to oblige. In 1937, a national radio show paid his expenses to New York so that he could appear on the show. His courage was inspiring to everyone who listened in that night. He had recently discovered a rich ore pocket, and Heinie was asked how he could tell whether or not ore was valuable. He happily explained that he could tell gold by its taste.

Leprechauns

The man who shared this story was proud of his Irish heritage. Born and raised in Goldfield, he loved nothing better than to spend hours talking about his childhood in the old gold camp. While he never encountered anything ghostly, he did have a rather strange experience, and to his dying day, he swore the following tale to be true:

I never will forget that day as long as I live. I was about eight years old when I saw the little people. My dad sent me out to the barn one morning to fetch some tools. When I opened the barn door I saw these little people scurrying to hide from me. They couldn't have been more than four or five inches tall and they seemed to be pretty scared of me.

I said something like I'm not going to hurt you. Come here. Don't be afraid. They stayed hidden in the shadows. I got the tools and ran back to the house to get my dad.

"You've got to see this, Dad. Come on!" I yelled pulling him toward the barn.

But once we got there they were gone. I looked high and low; the little people were nowhere to be seen.

"Leprechauns," my dad laughed. "You saw the leprechauns."

"Did you see them too?" I asked.

"Not too many people are lucky enough to ever catch a glimpse of a leprechaun, son."

"Will they come back?"

"No. Once you took your eyes from them, they vanished…They'll not return here."

He was right. I never did see them again. Folks can call me crazy all they like, but I know what I saw that morning.

Who Was the Galloping Ghost?

After the gold rush, most of the movers and shakers relocated to northern or southern Nevada. There wasn't much going on in Goldfield anymore. Newspapers had little in the way of local news for their readers. But one day in July 1916, an article appeared in the *Goldfield Tribune* that stirred readers' imaginations. The story, entitled "Galloping Ghost Is Cause of Excitement," told about a mysterious will-o'-the-wisp that had been seen the

night before on East Crook Street. The first witness to the ghostly goings-on was a youngster by the name of Billy Wilbur, who lived between Sundog and Blake Streets.

When pressed for a description, Billy said the specter was dressed all in white and covered with a white veil. Curious about the apparent visitor from the hereafter, he tried to follow it for a closer look. But to Billy's dismay, the ghost turned and started running straight for him. Unable to get out of the way fast enough, the boy was knocked down. Never had Billy seen anyone— much less a ghost—make such a jump.

When the fleeing ghost, with Billy on its tail, sped past Fred Moore's front porch, Moore gave chase as well. He and Billy gave up at the Sundog School. The ghost kept on running.

Later, Moore said he believed the ghost was not a specter from the hereafter but a man dressed in a woman's clothing. While plenty of people in Goldfield saw the ghost, no one knew who it was, where it came from or where it was going. As far as anyone knew, it was the first and last time this particular ghost ever made an appearance.

A DEPUTY'S STORY

The deputy sheriff who shared this story with me has long since retired:

Several years ago, myself and another deputy who worked the graveyard shift were taking a break in the patrol car at the corner of Main Street and Highway 95 [Crook Street]. Rain had fallen most of the day and night. A block away, the old Goldfield Hotel sparkled like new. The rain finally stopped halfway through the shift. The town had received a good soaking; Highway 95 was still slick and wet. The gutters and ditches were thick with mud.

We discussed people we had known, calls we had been on and our favorite football teams. It was idle chitchat that helps to make those last few hours more tolerable. I was in the driver's seat and absently glanced in the side view mirror. That's when I saw this guy coming toward us. He was walking right down the middle of the street and didn't seem to be bothered by the cold or the damp.

"Helluva night to be out on foot," I said to my partner, who turned to stare through the back window.

"Wonder what he's up to?"

"No telling. Probably had a fight with the missus…or ran outta smokes."

In a town the size of Goldfield, you soon know everybody here, at least by sight. This man was a stranger to me.

"He look familiar to you?" I asked.

"Nope, must be visiting someone."

"Could be, but why come out in this?" I asked, knowing full well that I'd be home curled up with a good book if I had my druthers.

Conversation stopped as we focused on this person who was nearing the patrol car. When he got about even with the driver's window we could see that his coat was long and tattered. He turned his head slowly from us, ducking it to his chest as if to shield himself from our sight. If this is what he intended to do, it had the opposite effect. We were alert and watching closely as he walked passed. Then, without even looking for cross traffic he walked out into the middle of the highway and vanished. One second we were watching him approach the middle of the street and the next he just disappeared. We looked at each other; our expressions said it all. Neither of us said a word. There was no need to. We knew what we had just witnessed; we also realized there was no earthly explanation for it. We didn't talk about that night again.

I have parked at the corner of Main and Highway 95 many times since then and I've never seen anything like that. It may have been a ghost of some sort, I don't know. Al I know is it was the strangest thing I've ever seen.

Haunted High School

Built in 1907 at a cost of $100,000, the old Goldfield High School opened its doors in 1908 to 125 students and 25 teaching faculty, graduating its last class back in 1947. The school is well known to ghost hunters. Of course, it's a historic and architecturally interesting old building, but it's the ghosts that linger here who fascinate us. If you believe that objects can be haunted, then you will be interested to note that some of the sinks and other fixtures from the old Goldfield Hotel are stored at the school. During an early investigation of the school, a psychic zeroed in on the bathroom, believing the ghost of a little boy to be there. The child was happy to be acknowledged but confused about the passage of time. Why was he here? Where were his mom and dad, his classmates and friends? The psychic calmly explained to him that they

Goldfield High School. *Photo by Bill Oberding.*

had long ago moved on and offered to help him toward the light if he chose to go. He didn't. Contrary to what some might do, the psychic wished him well and went on with her investigation. Ghost sightings at the high school include students and Mary McLaughlin Hatton, a former principal.

The Goldfield Historic Society hopes to restore the building to its former glory, but there is much work to be done. The restoration project is going to require a lot of donations.

Years back, I was invited to take part in an investigation of the school. A local television news team wanted to do the annual Halloween ghost spot, so here I was in Goldfield, looking for ghosts. The team, which consisted of five ghost researchers, would attempt to gather evidence that the hereafter is real and not just the stuff of scary movies and campfire tales.

Thankfully, the owner of the old Goldfield High School building was agreeable to allowing us access. Yes, the news media does open doors. After a cold night at the Goldfield Hotel, we drove over to the school building. Once inside, it was easy to see the extent of damage the desert clime had done to the building. It was dusty as we walked. There would be a lot of dust

Goldfield High School, with original sinks from the Goldfield Hotel. *Photo by Sharon Leong.*

orb photos later. Someone heard something, possibly laughter. At one time, there were nearly four hundred students enrolled here. Imagine the noise as they trudged toward their classes each morning. On this night, the building was eerily silent, except for the wind whistling through the walls that no longer held out the cold. This old stone building was constructed about the time that Goldfield was roaring, when this was the largest town in Nevada. Now there are fewer people in town than this school was originally built to accommodate.

Someone saw the ghost of a young boy. With cameras and recorders ready, we attempted to capture his likeness or his voice.

"Duck!" someone else yelled. Something swooshed overhead, screeching. Had we disturbed an owl? No, too small. On its second pass, we realized what it was.

"A bat!"

"Eeeeeek!" shrieked one of the investigators.

"Don't let it get in your hair," advised another.

"Bats carry rabies, don't they?" someone asked.

"Duck!" shouted someone else.

All ghost hunting forgotten, we agreed it was a fascinating building and beat a hasty retreat. Some places are better by daylight. This may be one of those. Besides, bats are nocturnal and are sleeping at that time.

The restoration of the old school continues in earnest.

DIAMOND TOOTH LIL AND THE RED-LIGHT GHOSTS

During its heyday, Goldfield had a very large red-light district, a well-known area of town where brothels and crime existed freely. My friend Virginia Ridgway lives in the middle of what was once the red-light district. Nothing remains but a few tumbled-down buildings, the sand and the weeds. Mobile homes dot Main Street on lots where the brothels and saloons once stood.

Whenever I visited Virginia during the summer months, before her fall, we would walk to and from the Goldfield Hotel, about a block away. When the wind isn't blowing down from the Malapai, this area is usually eerily silent. But not always—occasionally the sounds of laughter and gaiety can be heard emanating from these long-ago establishments, like the dance hall of Diamond Tooth Lil, one of Goldfield's most famous madams, where the likes of Diamondfield Jack and other notorious bad men hung out night after night. Here in the red-light district at Victor Ajax's famous Sunset Café is where one man shot another to death over a two-timing wife. Here in the red-light district is where the most famous ghost at the Goldfield Hotel, Elizabeth, plied her trade in life. Or did she? While Elizabeth may well be the stuff of legends, we know that many young women came to Goldfield

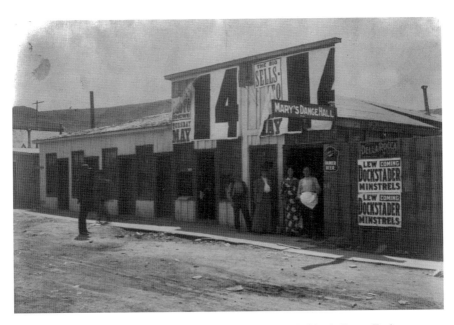

Mary's Dance Hall in the Goldfield red-light district was probably similar to Evelyn Hildegard's dance hall. *Library of Congress.*

119

Ghost hunting in the red-light district with an infrared camera. *Photo by Anne Leong.*

only to end up working in the brothels. Some married wealthy men and moved on, some died lonely deaths here in the gold camp and some, like Diamond Tooth Lil, went on to bigger and better things. Then there are those few who haunt this area of town, unaware of the passage of time. If the sounds of hilarity and good times are any indication, they are enjoying themselves in the afterlife very much.

Listen for tinkling champagne glasses and a raucous laughter. Some of these sounds have been recorded as EVP during impromptu recording sessions. When asked, "Can you tell us your name?" a female voice that is particularly interesting responds, "I bet you know."

Perhaps it is the ghostly Diamond Tooth Lil returned to her old pied-à-terre here in Goldfield. If she is here, can Diamondfield Jack be far behind?

Diamond Tooth Lil was born in Austria-Hungary in 1885 as Evelyn Fiala. If not for her parents wanting a better life for their children than they themselves had known, Evelyn might have lived out her life in relative obscurity somewhere in Vienna. Diamond Tooth Lil would certainly not have been the household name that it was in the Roaring '20s. But the Fialas did want more, and so they packed up their children and sailed across the Atlantic. They settled in Youngstown, Ohio, where they worked hard and grabbed what they could of the American Dream.

The Fialas worked long hours to feed their family, and Evelyn grew into a beautiful teenager who daydreamed of fancy clothes, romance and true love. When she was fourteen, she met Percy Hildegard, and her girlish dreams were answered. He was as enchanted with her as she was him.

The young lovers sneaked away to Chicago and got married. But Evelyn's happily-ever-after didn't last very long. Alone in a strange city, she found a job as a singer in a local saloon, and thus began her singing career.

Other marriages and divorces would follow. As an elderly woman living in relative obscurity, she would remember thirteen husbands, yet she kept the name Hildegard all her life. Evelyn Hildegard was her professional name, until she became Diamond Tooth Lil.

She was singing in San Francisco when the 1906 earthquake struck. With the city in shambles and engulfed in flames, Evelyn decided to pack up and leave. Goldfield, with its wealthy citizens and all those millions being produced in its mines, was just her sort of town.

To the delight of his customers, Tex Rickard hired her to sing at his Northern Saloon. Years later, she would say Rickard had generously paid her $200 a week for her services. She took Goldfield by storm. With her repertoire and good looks, she was soon packing them in. Within a few months, she opened her own dance hall: the Nevada Club in the Tenderloin, across the street from Victor Ajax's Sunset Café.

Evelyn's stay in Goldfield was short lived—less than a year—but it was long enough for her to meet and romance Diamondfield Jack Davis. Evelyn was impressed with his diamonds; Diamondfield Jack had a pocketful of them. Obviously, he was wealthy, and she wanted to be that rich. According to some, she would later win a bet with a Reno dentist, and it was in payment of the bet that he placed a diamond in her front tooth. And Diamond Tooth Lil was born.

Soon the beauty with the sparkler in her front tooth was the talk of the town. Opportunity beckoned elsewhere, and true to her nature, Lil heeded its call. In 1928, actress Mae West wrote and starred in *Diamond Lil*, a Broadway play that some thought was loosely based on Lil's life. This may or may not have been the case. There was at least one other woman who used the Diamond Lil moniker during the same time period as Evelyn Hildegard. This is why researchers often encounter some confusion between Honora Ornstein's Diamond Lil and that of Evelyn Hildegard. Both women were born in Austria-Hungary. The women were about the same age, both were singers and entertainers and they each had a diamond, or two, placed in a front tooth. While Ornstein's

Diamond Lil spent most of her time in the Klondike and the Seattle area, Hildegard traveled throughout California and Nevada.

Regardless of on whom the character Diamond Lil was based, Mae West's play was a smash hit. Five years later, she starred in the film *She Done Him Wrong*, loosely based on the play.

The real-life Lil headed out to Death Valley, where she operated a brothel for a while. She owned and operated such businesses in Idaho and California before settling in California. Diamond Tooth Lil continued to make the news. In the December 8, 1943 issue of the *Ogden Standard Examiner*, an article appeared about her running a tourist camp in Boise, Idaho. "We drank, but we didn't get drunk in those days," she recalled. "You can't have fun when you get drunk. And we were just out for fun."

She was again in the news in 1944 when she announced that she was remembering the Idaho Children's Home in her will. She was leaving the orphanage the diamond from her front tooth. The *Wichita Daily Times* of January 27, 1944, reported: "'When I die I want the tooth sold at auction and the money given to the Children's Home,' said the fifty-seven-year-old woman born Evelyn Fiala in a town near Vienna, Austria."

In 1966, Mae West successfully brought suit against a Los Angeles nightclub performer who was using the name Diamond Lil. West thought herself to be the only true Diamond Lil. Ironically, Evelyn Hildegard was penniless and living in California at the time.

The *Gazette Montreal* of September 8, 1967, reported:

> *"I used to have diamonds on every finger and hanging around my neck," she said in a 1963 interview, "When I was broke, I'd hock them."*
>
> *Fond of recalling her fun-filled life, she said once drank champagne in New York with a former Prince of Wales.*
>
> *"I've been every place I want to go and seen everything I want to see," she told a reporter in 1963. "I've had everything I ever wanted out of life."*

Evelyn "Diamond Tooth Lil" Hildegard died at the Claremont Sanitarium in 1967. But there's no stopping a determined ghost. Like the *Titanic* ghosts, Lil may have come back to Goldfield, led by her memories and love of the good old days.

ASHES, ASHES, WE ALL STAY AWAKE

I believe that ghosts can, and do, communicate with us in our dreams. This strange incident confirms it.

Whenever my husband, Bill, and I go to Goldfield, we generally stay in Virginia Ridgway's little apartment. It's a cozy place, although there is the occasional spider, but that's life in the desert for you. Much of the furnishing in the apartment is antiques that belonged to Virginia's mom and dad. There was something more the first night we stayed there.

I am the type of traveler who can fall asleep the minute my head hits the pillow, wherever I am. Bill is not. The least little uncomfortable thing, like a lumpy mattress or bright streetlights, will keep him awake. Thankfully, Virginia's apartment suffered none of those things.

We went to dinner with Virginia and her husband that night, and after a quick review of the following day's plans, we said our good nights, went to the apartment and prepared for bed. I was asleep, but it wasn't peaceful, with Bill tossing and turning and tossing. Finally, I was awake. I sat up in bed and sleepily asked what was wrong.

"I have been having the weirdest dreams," he said. "This old man was tapping me on the shoulder and telling me that something's got to be done. Over and over, he kept saying, 'Something's got to be done.'"

"Probably the chicken cacciatoria," I yawned.

"That's not it! This place is creepy, and I don't like it!"

"Well, try to get some sleep," I said, sliding back under the covers. "Think of something else."

Over breakfast the next morning, Bill admitted he hadn't slept a wink. "It was if that old man was right there in the room with us," he explained.

Virginia looked stricken with each word. "Uh oh, I just remembered," she said.

"What do you mean?" I asked.

"I am so sorry. To you two and to ———. I've been storing his ashes in that little box in the apartment. He must want me to do what I promised. I will have to go up to the cemetery and scatter them."

Bill and I looked at each other, and try as we might, we couldn't help but laugh. We've stayed in the little apartment countless times since that first night, and Bill has always slept soundly. The old man hasn't made another appearance in Bill's dreams since Virginia scattered his ashes.

BIBLIOGRAPHY

Boor, Jackie Logan. *The Honorable Life and Scandalous Death of a Western Lawman.* Brule, WI: Cable Publishing, 2014.

Cafferata, Patty. *The Goldfield Hotel Gem of the Desert.* Reno, NV: Eastern Slope Publishers, 2005.

Carlson, Helen S. *Nevada Place Names: A Geographical Dictionary.* Reno, NV: University of Nevada Press, 1974.

Chaput, Don. *The Earp Papers: In a Brother's Image.* Encampment, WY: Affiliated Writers of America Inc., 1994.

———. *Virgil Earp, Western Peace Officer.* Encampment, WY: Affiliated Writers of America Inc., 1994.

Colorado Supreme Court. *Pacific Reporter.* N.p.: West Publishing Company, 1909.

Earl, Philip. "The Barieau-Logan Murder Case." *Henderson Home News and Boulder City News,* July 1987.

Elliot, Russell R. *Nevada's Twentieth-Century Mining Boom: Tonopah, Goldfield, Ely.* Reno: University of Nevada Press, 1966.

Ellis, Ann. *Life of an Ordinary Woman.* Boston: Houghton, Mifflin and Company, 1929.

Fisher, Vardis, and Opal Laurel Holmes. *Gold Rushes and Mining Camps of the Early American West.* New York: Carlton Press, 1968.

Harrell, Beverly, with George Bishop. *An Orderly House.* New York: Dell Publishing Company, 1973.

Housley, Kathleen L. *Fire and Forge: A Desert Railroad, a Wonder Meta, and the Making of an Aerospace Blacksmith.* Bloomington, IN: iUniverse, 2014.

Hunt, William R. *North of 53: The Wild Days of the Alaska-Yukon Mining Frontier, 1870–1914.* New York: Macmillan Publishing Co., 1974.

James, Ronald M. *Temples of Justice.* Reno: University of Nevada Press, 1994.

Kintop, Jeffrey M., and Guy Louis Rocha. *The Earps' Last Frontier: Wyatt and Virgil Earp in the Nevada Mining Camps.* Reno, NV: Great Basin Press, 1989.

Lingenfelter, Richard E., and Karen Rix Gash. *The Newspapers of Nevada: A History and Bibliography, 1854–1979.* Reno: University of Nevada Press, 1984.

Lowe, Celesta. "The Hex of Harry Stimler." *Golden West True Stories of the Old West Magazine,* July 1967.

Magnesen, Gary. *The Investigation: A Former FBI Agent Uncovers the Truth Behind Howard Hughes, Melvin Dummar and the Most Contested Will in American History.* Fort Lee, NJ: Barricade Books, 2005.

McCracken, Robert D. *A History of Tonopah, Nevada: 1966.* Tonopah, NV: Nye County Press, 1990.

Myhrer, Keith. *World War II Training Crashes at the Tonopah Army Air Field, Nevada.* Edited by Allen Metscher. Nellis Air Force Base, NV: United States Air Force Air Combat Command, 2010.

Porter, Shirley A. *But You Can't Leave, Shirley.* Reno, NV: Western Book Journal Press, 1992.

Raymond, Elizabeth. *George Wingfield, Owner and Operator of Nevada.* Reno: University of Nevada Press, 1992.

Reid, Ed, and Ovid Demaris. *The Green Felt Jungle.* Mountian View, CA: Ishi Press International, 2010.

Shamberger, Hugh A. *Goldfield.* Carson City: Nevada Historical Press, 1982.

Thomas, Charles S. *Silhouettes.* Caldwell, ID: Caxton Printers Ltd., 1959.

Zanjani, Sally, and Rocha Guy Louis. *The Ignoble Conspiracy.* Reno: University of Nevada Press, 1986.

Zanjani, Sally. *The Glory Days of Goldfield.* Reno: University of Nevada, 2002.

———. *Goldfield: The Last Gold Rush on the Western Frontier.* Athens: Swallow Press/Ohio University Press, 1992.

ABOUT THE AUTHOR

An independent historian, Janice is a past docent of the Nevada Historical Society and Fourth Ward School Museum in Virginia City. The author of numerous books on Nevada's history, true crime, unusual occurrences and hauntings, she speaks on these subjects throughout the state. Her Ghosthunting 101 and Nevada's Quirky Historical Facts classes for Community Education at Truckee Meadows Community College have been well received.

Visit us at
www.historypress.net
..
This title is also available as an e-book